PORTRAIT AND DREAM

ALSO BY BILL BERKSON

Poetry

Saturday Night: Poems 1960–61 (Tibor de Nagy Gallery Editions, 1961; expanded edition, cover painting by Norman Bluhm, Sand Dollar, 1975)

Shining Leaves, cover by Alex Katz (Angel Hair Books, 1969)

Recent Visitors, cover and drawings by George Schneeman (Angel Hair Books, 1973)

Enigma Variations, cover and drawings by Philip Guston (Big Sky, 1975)

100 Women (Simon & Schuchat, 1975)

Blue Is the Hero: Poems 1960–1975 (L Publications, 1976)

Red Devil, cover by Lynn O'Hare (Smithereens Press, 1983)

Start Over (Tombouctou Books, 1983)

Lush Life, cover design by Joe Brainard (Z Press, 1984)

A Copy of the Catalogue (Labyrinth, Vienna, 1999)

Serenade: Poetry & Prose 1975–1989, cover and drawings by Joe Brainard (Zoland Books, 2000)

Fugue State, cover painting by Yvonne Jacquette (Zoland Books, 2001)

25 Grand View (San Francisco Center for the Book, 2002)

Gloria, etchings by Alex Katz (Arion Press, 2005)

Parts of the Body: a 70s/80s Scrapbook (Fell Swoop, 2006)

Same Here, drawings by Nancy Davis (Big Bridge, 2006)

Our Friends Will Pass Among You Silently, cover painting by Vija Celmins (The Owl Press, 2007)

Goods and Services, cover painting by Mitch Temple (Blue Press, 2008)

Collaborations

Two Serious Poems & One Other, with Larry Fagin, cover by Joe Brainard (Big Sky, 1972)

Ants, with drawings by Greg Irons (Arif, 1975)

Hymns of St. Bridget, with Frank O'Hara, cover by Larry Rivers (Adventures in Poetry, 1975)

The World of Leon, with Michael Brownstein, Larry Fagin, Ron Padgett, et alia (Big Sky, 1976)

Young Manhattan, with Anne Waldman, cover by George Schneeman (Erudite Fangs, 1999)

Hymns of St. Bridget & Other Writings, with Frank O'Hara, cover painting by Alex Katz (The Owl Press, 2001)

What's Your Idea of a Good Time?: Interviews & Letters 1977–1985, with Bernadette Mayer (Tuumba Press, 2006)

Bill, with drawings by Colter Jacobsen (Gallery 16, 2008)

Criticism

Ronald Bladen: Early and Late (San Francisco Museum of Modern Art, 1990)

The Sweet Singer of Modernism & Other Art Writings 1985–2003,
cover painting by Alex Katz (Qua Books, 2004)

Sudden Address: Selected Lectures 1981–2006, cover drawing by Philip Guston (Cuneiform Press, 2007)

Editor

In Memory of My Feelings by Frank O'Hara,
illustrated by 30 artists (The Museum of Modern Art, New York, 1967)

Best & Company (1970)

Alex Katz, with Irving Sandler (Praeger, 1971)

Homage to Frank O'Hara, with Joe LeSueur (Big Sky, 1978)

The World Record, with Bob Rosenthal (The Poetry Project, 1980)

What's with Modern Art? by Frank O'Hara (Mike & Dale's Press, 1999)

Portrait and Dream

New and Selected Poems

Bill Berkson

COFFEE HOUSE PRESS
MINNEAPOLIS :: 2009

COFFEE HOUSE PRESS books are available to the trade through our primary distributor, Consortium Book
Sales & Distribution, www.cbsd.com or (800) 283-3572. For personal orders, catalogs, or other infor-
mation, write to: info@coffeehousepress.org.

Coffee House Press is a nonprofit literary publishing house. Support from private foundations, corpo-
rate giving programs, government programs, and generous individuals helps make the publication of our
books possible. We gratefully acknowledge their support in detail in the back of this book.

To you and our many readers around the world,
we send our thanks for your continuing support.

LIBRARY OF CONGRESS CIP INFORMATION
Berkson, Bill.
Portrait and dream : new and selected poems / by Bill Berkson.
p. cm.
ISBN-13: 978-1-56689-229-2 (alk. paper)
ISBN-10: 1-56689-206-6
I. Title.
PS3552.E7248P67 2009
811'.54—DC22
2008052607

PRINTED IN CANADA
1 3 5 7 9 8 6 4 2
FIRST EDITION | FIRST PRINTING

ACKNOWLEDGMENTS
Versions of some of the poems included in the section of recent poems, "After the Medusa (2001-2008),"
appeared in: *Gloria*, with etchings by Alex Katz (Arion Press); *Our Friends Will Pass Among You Silently*
(The Owl Press); *Parts of the Body: a 70s/80s Scrapbook* (Fell Swoop #78); *Goods and Services* (Blue Press);
Bay Poetics, edited by Stephanie Young (Faux Press); *Shiny; New American Writing; Big Bell; Court Green;
Sentence; Exquisite Corpse; Coconut; Shampoo; Big Bridge; Last Night's Dream Corrected; New York Poets II*,
edited by Mark Ford and Trevor Winkfield (Carcanet); *The i.e. Reader; Zen Monster;* and *Jacket*. "A Lady
at Her Writing Table" appeared as a Trembling Pillow Press broadside. "On *West Slope*" was commis-
sioned by Colby College for the catalogue *50 Years of Collecting at the Colby College Museum of Art*.
A broadside of "For the Heart of the Second Floor" accompanied an exhibition of works by Ishan
Clemenco, Susan Martin, and Nina Zurier at Margaret Tedesco's Second Floor Projects.

Grateful acknowledgement to the editors, publishers and designers of those publications, as well as,
through the years, Roland Pease, Larry Fagin, Curtis Faville, Simon Schuchat, Wesley Tanner, Kenward
Elmslie, John Bernard Myers, Lewis Warsh, Anne Waldman, Charlie and Mary Lou Ross, Michael Wolfe,
Peter Waugh, Albert Flynn DeSilver, Marie Dern, Steve Woodall, Andrew Hoyem, Jack Shoemaker, and
Kevin Opstedal.

Special thanks to the staff at Coffee House Press and to Miles Champion.

Deepest gratitude to Ed Ruscha, Moses Berkson, and, as always, to my wife Constance Lewallen.

This book is for my grandchildren,
Estella, Lourdes, and Henry.

ALL YOU WANT 1959–1961

OUT THERE 1962–1972

PARTS OF THE BODY 1973–1983

START OVER 1979–1980

A COPY OF THE CATALOGUE 1984–2000

AFTER THE MEDUSA 2001–2008

All You Want

1959–1961

OCTOBER

I

It's odd to have a separate month. It
escapes the year, it is not only cold, it is warm
and loving like a death grip on a willing knee. The
Indians have a name for it, they call it:
"Summer!" The tepees shake in the blast like roosters
at dawn. Everything is special to them,
the colorful ones.

II

Somehow the housewife does not seem gentle.
Is she angry because her husband likes October?
Is it snow bleeds softly from her shoes?
The nest eggs have captured her,
but April rises from her bed.

III

"The beggars are upon us!" cried Chester.

Three strangers appeared at the door, demanding ribbons.

The October wind . . . nests

IV

Why do I think October is beautiful?
It is not, is not beautiful.
 But then
what is there to hold one's interest
between the various drifts of a day's
work, but to search out the differences
 the window and grate—
but it is not, is not
beautiful.

v

I think your face is beautiful, the way it is
close to my face, and I think you are the real
October with your transparence and the stone
of your words as they pass, as I do not hear them.

MARCO POLO

Coming down from the mountain he thought
where oh where is the den of thieves
and where in changeable February are the ashes
of my dead father that have been my guide
these many years Suddenly the emperor rose up before him
letting a small fleet be seen behind him he said
there past the railroad our scouts have discovered
a neat highway where you can go and stop
bothering us with your questions and problems

And so he left the pagoda and the uneaten olives
and Fu Fu and her pets and started out home
with the sun growing behind him

ALL YOU WANT

The alarm of a lighter morning breathes before your eyes
in pools of smoke that smell ridiculously like someone's raised eyebrow in a cyclone.
It is complete to be dying, slightly, today, and to want as if the leaf
of your thoughts were pointing upwards at a field of hay in which a savage
has stuck some awful message: "The soap is in your eyes, the fever's at your feet,
where you sit is a honeycomb on which you're stuck, and it's safe to avoid the pleasures
of the threshold." Sunday is like any other day of wires
stretched across your torso like a tie of red and gold on which a clock has set
its chimes. It's dull to always weave a serpent from the air, and all the levees
have sunk beneath your boat that goes and never falters like the clock striking two
(the bars have opened, the churches have closed), and everything will have
a gleaming ring of stones around it as the windows remain full of palms.
To "open": a precarious waking, the wrists turned upwards. And you know
that sentimentality is the razor you walk on as a bird finds its boring nest.
Sparks are strewn about the sidewalk, August is a matchbook, and your hearts
flit with violence for striking in the surf of what you hope is activity
with your chest bared to the closing room of what you are and all you want.

POEM

1

You showed me the greatest poem of the century
And then I wrote the greatest poem of the century.

2

You are my poem:
You are therefore unknown to me.

3

They wore their bicycle pumps to the game.
It was raining.

4

We have taken our bicycle pumps to our hearts.
We are in love.

5

Bicycling was his love,
He of the tumbling stairs.

6

Death was on the road.
The neighbors waved.

7

O blessed perfection!
We kissed the open window.

8

I threw your bicycle pump through the window.
I threw your window through the air.

9

I move yellow to the window,
A solemn ritual of rhyme!

10

O jukebox in my bedroom!
I glued your envelope to my heart.

11

Poem! This is so interesting,
But is it real?

12

"Elaine et Otto 1958"—O, sûr que oui!
Les fleurs sont tombées mais les fruits commençent à nouer.

13

Are you so sure?
Have the flowers really fallen, or risen?

14

Like times upturned and headaches,
Leafhoppers! We burn.

15

"I never loosen my belt;
I am a spray of shoes."

16

The Daughters of the Eclipse have darted
The singular huddling flags.

17

Succinct beetles relation,
This hip actions caterpillars against the Amiens sky.

18

O bicycling! O whispers! O permitted sky!
"So saying, he took a candle and set fire to the house."

POLLYANNA

Across the backyard fence
the young 'un stretches herself
in a polkadot timidity
back from the wars
an acorn opens beneath her

it is time to clean up
and to sew on
the new highway she has dreamed of

while swimming in the muck
yesterday

CHRISTMAS EVE

for Vincent Warren

Behind the black water tower
under the grey
of the sky that feeds it
smoke speeds to where a pigeon
spreads its wings

This is no great feat
Cold pushes out its lust
We walk we drink we cast
our giggling insults

 Would you please
leave the $2.50 you owe me
I would rather not talk about it
just now Money bores me I would like
to visit someone who will stay
in bed all day A forest is rising
imperceptibly in my head
 not a civilized park

I think it would be nice this "new
moral odor" no it would not mean
"everything marching to its tomb"
 The water tower
watches over us Is there someone
you would like to invite no one.

STRAWBERRY BLOND

Knock on the forehead
there, there beach nothings
saw, reef, watery exchanges
of life O's not followed by
anything turf True?
(ringlet) (broadcast)
in wing around immortal portraits, are they?
the be-hanged cuneiform
money sniff)

rung ticker
a refusing passion
for burn on, brief nail!
under the sheets a lip
hits the sulfur stripe
phone book being a strength
a) (its Irish sequel)
b) paralysis mustard
back on the office
the rifting phlox
looks and wins
what cabinet of ruse and doubt
 gives him the possibility of love and honor through her eyes,
a doubtful sign of rain showing up on the back porch on which they swung
out the years of his death and on which she sat like an expectant mother—that
was unblackened!

Chocolate
tiding over the gray embittered court

he prayed for his marriage
as was the modern custom as if promiscuity were
 well, Stupid! finding tics

What am I indicting that it breaks heads off gardenia?

 green green stovepipe
 arm around me stalk wherein pegged a relax bus
 globule of often-candelabra in the cake
 of soap she saw her face a few times
 feather in his blood
 margin eat shit if
 in it old waterhole
 rub-down, shower, and melted

 in her sleep

 he woke up

 they went off socks

NEVER

> Sucking pleasure from a yellow
> there a bean stalking ground
> cold, bands eschewed apron, my mauler
> honey
> and singing caps on hair
> (in the breeze) (in her face)
> off the bat, the balls, and the old
> fence
> basket of groans delicate

it was a big gyp
movie hypnotic no
where the raincoat has settled
the horrible age I like
like answered things
shelved acorn ripplings ah
declare unsafe for the message
scrofulous inmates massage
so did . . . whole wheat secret
offish did its titular run
around the block ain't
gingerbread for it
what tissue caper drew a rose's sprouting

 . and then he had left her there where the path
to the miner's shack started up and became uncontrollable. Finally, they
put her to bed. "Dead Weight." She leaned on his elbow and kissed over
the falling sequoia on the balcony. "What could I do? He never took my
number!"

Pie
hustling for training

in the deep tower where rasped we're off
to enjoyable Albuquerque
he blamed everyone
for Indian Summer

and now it was the door's
turn to beat him up

What surrounded bawl-out paint evergreens me that I weep?

shut-ins of the world
meatball
in-icebox whispers and outhouse my
maharajah grippe flew with it
you snow only
a leap Hoboken simians
a few years faster comfort
trash it stepped under

out of the box

into the hay

one shot of snooze

SATURDAY AFTERNOON

What would the new fork bring me? and why
are porticos assuming sulfur? Leave its
cowbells charge is forces on the husks It is
no special translucence we bring to you, Dick and
Scarab, my ring of electric, morning

 interested in
 like a respectable mechanic
 and no other kind
 "motion of the earth from the force acting between the"
 action of the far-off sun
 hat buttons
 cannot digest

whether sickness or a particular evasion (picture) (connect)
of variousness's tulip it is not true nothing?
and so will not be concerned with eating afternoon

 divested of
 the ambulance
 it was no
 certainly not
 accident
 he had died

 a bowl of the most beautiful
 cereal hand me a bed goodbye
 forming a closed circuit
 no material actors those berths
 in his turn on a black
Settle for ginger ale in the
Big House resumed the habit of smoking
 feelings which I am always finding

under something which is a leather
walking piece
high on the knees of it, body
kicking them with the slipknot of ice

Lafayette

to carry our conviction slap
praising "who . . . whatever was distinctively human"

lipstick

the wrapping that consoles me in the night
chocolate—will fail by undirected love which seems
must glow like a baton on the wet track orchestra of rain,
passes through the sepulcher of diffuse kisses studded wire,
filthy with silk, for each time is rubbing on its jars
its portable fears, laundry sirens and moon he crystalled it
and everything is preceded by it, blindfolded in its
sanctity to the nth gum—(ground slipping unexpected when it)
(less whistling and gray) holder of rain, shingle erasure (on his lips)

STILL EARTH

I'm wondering how to fill it, that sack you left me
of sky, redundant as an egg, entering the breakfast room
with a careless smile—a very abominable women, then
that was another crime, never loved any of them, is it
interesting?

Glad to be relieved
without the production the household
of any sensible result brute

 I cannot patiently endure
 the twig or any inches
 and let alone his failing
 if of he will have had it so
 for two or three weeks and then
 the plot
word of a big-eared, stoop-walked . . .

 how his love became him! because
 it was never there the convergence heap

Bulbous

the venetian blinds tabling and the diamond being late
these passions for utterance, the whatnots barned in drinking
tonic and embracing her, his fingers to his nose, the agitation hatband
guitars, for oh! it is a pair of glasses, groundless with blond hair
"Because you never understood me, Swell of the Corn" barbells
supposed him otherwise it would have been the hawk and hunk of it
a red smear, and I had found the model of my ninth-year foul line
it was a rust . . . bit holes in the cigarettes certainly uplifted
by a few flat decisions—glance of case of, anxiousness waxed
The syndrome (was nursed) (opened) along its (noose) causeway
suspecting them, my petaled foot not among them

POEM FOR JOE LESUEUR

1 *To The Hunted*

Throwing away that mellifluous camouflage you sprint
for taller grass and the barks that will hide you
differently than the torrents to which you had become
accustomed You opened the shack door with a knife you borrowed
from the table of your last protectress Now it is raining
differently You walk across the dirt floor and take
the last berry sitting squarely in the chair Now
the sun is shining as you eat the berry and a new
plan is throbbing in your head Kill! Kill! You
leave the dirt and the hay and the adobe altogether Life
has become another aspect of a different thing Love
is casting itself at your feet You sit outside
on a rock that is drying itself as if with matches
and the trudgings in the brush are still

2 *The Neighbors*

In another room the same chatter continued. Oyster shells were being broken,
and the whole evening had taken on the atmosphere of a pleasant rout. The
waiters were leaving as had been expected. She couldn't care less—it was
harvest time after all and the moon was seeming still over the spikes of the gate.
When the young boy raised his foot and placed it softly over hers, she no longer
thought of swimming.

STATUES

Everything comes to a head. Does this mean sculpture?
I am thinking of an answer with gray, concrete hair:
What is it? It is an orange growth somewhere
beneath the subway. One leaves the subway
and is hampered by a park. These are airless un-
 certainties from which to swing. It is sure,
the children should be someplace else, in a van
moving southward.

HISTORY

I

 Carried away by what was after all
arrows faster than wind
 stopping traffic.
The chairs are their guardians as hands
stop the wooly harps, *mein liebchen!*
sound as a heart in love with darkness
 though keeping from loneliness
 by trickery of oneself, satisfied,
 crumbles, not understand
 but imaginable
even with this mountainous street,
 himself—
things pass as if searching for ice
who shape themselves with smoke
 rising—
do they manage to sleep sometimes?
 "a" criminal—the new ones
Trying to understand what it is actually like
on a balcony with one's hat off
 though distinguishing between actual despair
 and trickery
 a certain passivity of habit . . .

 History itches.
whose relaxed nature has been in the service
of several trees clustered as they might
around the aridness of the town's one street
burning, dully, the apricots sufficed as heads
for the landscape. It is again summer.
 as if to understand and live in silence—
 its mouth

where the ashes of ordinary sparks fire and fire again
into a not unimaginable freedom as if straightening up
for the first time to face the last onslaught of factual wind
 as if you could have it done "right now"
 and someone opens the car door right onto a beach
 and says, "This is your Cythera, have a run"
 and children jump from your back
unhurt, into the sand which divides them from you
 must at nighttime losing perplexity, a museum
 destined to be presented, eating candied fruits.

Several of them
 repeatedly sanded
several of them
neatly on board
 crossing the Mississippi with a sense of shame behind them
 outlined his arsenical nature, vitriolic, for troubles
 that Mr. B. does not specify, chiefly by women and spleen,
 it was recommended, for the strings,
 "an almost universal complaint"
that you must
 the trappers
 lives quickly
 cardboard of screams
 into road during narrow assassins
 has spoken of France and its expectations
 of homage, my young friend, haven't we?
a tavern or from a club
 a line disappearing from his mouth
 a tune

2

 they sang it, "Left."
 upon to control her wishes
 it is even stranger to build a

cabin out of them niches
their carrions left on the back
porch for all to see, it is
hard to feel hate for those who weep
regularly and on some whose blossoms
lean outward. I can remember more
than my natural portion of confusions
at the thought of love and other
convictions like spraying the mist
with your own and sometime divine
breath to some conclusion raucously
and believe wholeheartedly in the
 "XXième Siècle Américain"
 as designed
 by beautiful obstacles
 to search out the seasons with a loosened heart
 aware of weakness interminably choosing
rather to find (discover, as in trees) than to win hopelessly
with intrusions of thought and density coming to caring always
 as designated
 "with poetry or anything else"
 with the ordinary river before us
 and the windows streaming by
 as if you were driving the intemperate car
instead of standing still and growing upwards

 it is baffling to be baffled by taller men
 to be preoccupied by their grace (learning
 their awkwardness later and too late)
 so that the sachem will guard his tribe
 from history as from an enormous boat,
 they will risk disobedience for their visions
 so become the desert itself
 with the modesty of a chameleon
 and changes

beneath their hood of ice
in those red shirts and leather belts
ecstasies abounding drifts telephone hole.
The news of his banishment became known. Some disturbances
the reef's gift twice abandoned
in perilous times
with the scent of China crashing from his lips
that he should cancel, privately, tinctured
and tremendous with message aches
happened

3

"Yes," rejected Roscoe, "she is."
the new
Tammy was surprised she didn't know them.
delightfully stained

4

collars of pity from their necks to knees
keenness thwarted the diet prepared of ages
kaleidoscope "Rien n'y va plus" perceives
the smallest of them kissing the shore

The perfumed drought of mind
not even to construct in this mess
the kind of home where a match falls free
but not airless, bottles with pictures in them

"He brought her from that spot to Beaulieu, remembering Belle Terre,
crossed in front of the car at St. Jean where he fell at her feet in such a
hurry that she started before he could say a word.
crust became a familiar object in the streets of the place
childless, and never so happy as when feeding
watched the North Star from a tent at the boys
camp, thinking of monsters as one thinks of pets one

has left behind: "Now tie him to the tree

bare assed and pass in review." would not return

til very late if at all, and forget the meal

which continues fully listened sees its image

 paints

destroyed in the making

 which if artless would have (if) as true

with a look

 its viewers

 it was particularly Life

 for him that

 hard that evening

5

 King Philip King James King George Valparaiso
 cancel this
 among the nickels he found too
 for a soda-lined whirl of the extreme
 a questioning public—publicans
 feeling that he was expressing himself
 as a child
 with handball
 had an admiration for spots
 But the Mississippi is truly unimaginable
 for in the shade that falls frighteningly close
 to us as we go our way—an act in itself,
 remember?
"to the Greeks who exalted whatever was distinctively human"
 wings cannot escape but alter because they are
 with the genius recognizing the oarsman below
sweetness in it
 designed to marble as a warning to all below
fearing to show that attractiveness which is falsity, the criminals,
and the highest to fidelity of purpose
 without purpose following the gold

and afternoon walks in on a delicious drifting
after one last cigarette, had to the south
with the books scattered, he had before him the spray
quickly turned to cloud, formally kings in a great town
now clowns and companions to explorers
poison—a three annexed sand.
The hardened shadow, grown in light, embraces wind
with all its leavings
which has escaped its one body, against form
becomes a life, and the only one, gesturing to the plains
its wounded birth, lyrically . . .

the servants of self

patches

who would have killed are not private

footsteps ringing mountains

flares

are "loved"

BREATH

November! November! Smoke outrunning branches, reefs
turning hideous and cold, windows accepting porches
accepting the draft, the dust, its vacancies like the arctic
desert . . . the lead-dogs in heat, thirst of adventurers
for elastic, the bench, walk, and fountain certainties!
It is definitely a city like the top of something, the pole!

So we went walking in our breath—denying the tooth of it,
it was the sandwich, drying quickly color-deletion propellers
The conditioned button on our ears, we fastened it, shinily
being smart—November will not outlast it, it is a straight
red line around the heart's jacket, forming a grey one, it is
fur, fur for steel as ourselves, run it on your fingertip grate
like picking up a pencil, aware of the next-door cellar of fire
Mush! pull from out under the cellophane considered knocking, was it
candy, glue, a stick of bells? Snows snow on the mountain pedals—
it has not arrived immediately "they will be late as scissors"
 "they will be early as the knob"

The drawer finished and the collection without doubt burned
at its edges, beginning a new crossing with real paint, lacking
as would have it hinge a real armies with which to deal
Love comes but once to a shoe
and must be stepped on
if we, any of us, are to
survive . . . in its tracks, the moth
capered like his sailor-suit photo against,
my speedy dessert season, an armistice wrested
from the trees

RUSSIAN NEW YEAR

for Norman Bluhm

Now trouble comes between the forest's selves,
And smoke spreads to pools in which we stroke
Our several smirks, but the accident will not happen
For someone has stolen the apples
And someone else has "come full circle," picked at the fog.
Snow settled in the meetinghouse. "I love you as my own dear jailbird.
I cannot think of you without thinking of the New York lighting system."
Shame sneaks in the birches, a fire has been put out.
The distance is too much again, an army is raising the dust—
Are these horses we count as pets?

It is whiter than your face the afternoon I opened your icebox.
You are entitled to it, wisdom which bores us but may excite you
By the glint the pillows made on the horizon, unwounding silences
Mixing the poison I breathe and leave behind me
At the hitching post
 Her dress raised above her ears
She lay livid among the party favors She closed her
Umbrella It is a cape of black which turned the carousel
It is a bucket into which night has fallen It is no fun
Light and happy, the canyon.

My days are eaten slowly.
The pricks incorporate all jolly in the lurch.
I sit on the fluorescent seat.
All revolutions have betrayed themselves
By slush of feeling
For weakness will always burst from strength
The rose will shoot from the ground
As buildings stick in the wind and stop it a minute
Someone will remain

Of life riding into the trees to grow
A steamy stormer of storms.

Are you different from that shelter you
Built for knives? On the sidewalk, sapphires.
On the fifth floor, fungus was relaxing. I have put on
The crimson face of awakeness you gave me
What is that heart-shaped object that thaws your fingers?
It is a glove and in it a fist.

The shore slides out of the sea
Strength
To live privately beneath the noise
Of the sandbar budging
A rose above the eagle it was there
Tattooed Sumac above us Pain
Is spliced and ticked away by waiting
In the chair beneath which paste is dripping
And a match is lit

From today on it is sleep I leave you on the slow waterfall
One cannot even escape light
On the night's horizon, you believe that is pleasant,
Don't you? Or when it is snowing heat remains
In the cupboard—that too? . . . Thunder?
With you it is always the inconspicuous tear
With me it is never anything but money
Still we are the same . . . Sideways

HOW IT GOES

The doorknobs are burning their night . . .

I have placed you in a corner that you might be more
comfortable . . . It is a hospital bed you have traded
for an ashtray, avail yourself of it, this slippery steamroller
comparable to anything The plein-air hangars avail themselves of it
and the penholders and the fruit bowl in which the concrete
has finally come to rest—for everything is attached there came
its picture frame to the eleventh floor, spanking scenery

I'm through with seasons done also with sun
and the huge uncertainties—bring
me an oyster my match and its flame
to control the filing cabinet and drawer
a cardboard buckle for the shopping
bag wounded parading heels—I will let
their troubles be mine like a watch-
band Messenger, we except ourselves slipping
the key under the door Soldier, we admit to
orangish moons and tremble at their shadings
Brown book jacket! Orange car! Rippling the ruses
the soaking bar table bemuses the swimsuit racket
and we will never see summer again or the chair straws
they have been rubbed at the edges and left divining
the divine helicopters shows her hair off as a
factory object Gun in his suitcase
 sprayed

in my own cage of marble and stool bunches
lets me rest as I transpire in the mauve of me
as I exhale the flesh of it, perspire its lip-
stick-colored ripenings, and slip down upon it

like an animal balloon crying "Panther!"
it will surely be all right as will love if it
is emphasized enough on the fingertips—for it needs
its own attachment like cigarette paper on the destructible
desk Fucking the ash of it for its own sake becomes
heroic and bitten by woes of blinding heights in which
the ram sees clearly its precipice, clusters its children
about the glazed beckoning

There you are rising again from your corner.
It is your glove of herons that hurts you, it is not
that other person hitting you. The melons invite you,
you flee again the angry tropics, porches shaping dwarves,
then returning them to the snack counter—knowing the
mud of it, you reminded me, it was a suite of titles
planned for a larger work with a nose and some overgrown
hair, empty as a coal bin—who have succeeded
by scratching out their eyes, applying themselves to the floor,
love it as a birthday salute accurately it shaved evenings
for the rope around my neck, it is cloud seeping from
the rafters. Loaded zipper. Curb. All the neighing!
It was not a war, horse, it was a gift, confusion.
To burn them. It is my luck to have you
as a stationmaster, you asked me and I refused
to tell you. I lacked no openness, it was the
cough drop of pain you gave me and I thanked you rightly
for its flavor. The elevator sat upright in the snow.
It is to you wagon train that I end this pulling.
It is to you hatred that I eat this olive of care
which you have taken from me, lest the collars open
and the wind blow loose its ash. Who has not spit
from the bridge? "I left the deaths which
preceded me, I went to Paris, to walk again . . . "

It was for . . . particularly screen fired through it
(hard that evening) missed They led him at last
to his chair it belongs to him by dint of leaving
everything else took him at the quarter mile
presents as a caper the kingdom, that is his way
They wouldn't say it . . . Hermaphrodite
all secrets, victories pass their eyes
who are limping on the field
The lotion spreads. Blood. "I sought to settle
a million things, am now grown younger and at last
a fool. But it is the one thing that I can relax,
my heart." Goat of it blinking out the sugary pile!
 the legs of it Corinthian
unpardonable orchard—the tie clip, socks and belt
grown weary in their prohibitive gold (Novembrous
gulp) She wore it at the elbows It won the race
It would It soon tickle the old
vegetable can snaking in of his density the *gloire*
des tuyeaux became pan and was always to be a brush

She walked out on pulse- the wiry vermilion and seeded lawn
olive drab of the mugs convulsive like the hesitant barbell
wrang it out—wet for a few years of heretical fixture
in her shorts a rather chartreuse ice cream flipped for it
and came out heads over a field of smoked glass it was
a new orange drink . . . which the . . . provided the revolution
for as it had come from the very fruit would pass
as a vignette of synthetics old bat or eagle's web
someone mysterious behind the cello, wretchedly scherzo—
"You do not wish me to be someone else? the missing
handlebar on your newly discovered bike? or at least sit on it?
A revelation of the downhill in our thought?"
I was right to disbelieve the cyclone's hint the disaster
was enough and it's lucky you left me in time April
like my nurse's doorbell (fang! fang!) (jet-capped) merds

phone message to alleviate summit . . . the flag of athlete's
foot on its shoulder it goes eastward no one knows how
it's like winning the day but losing your dinner, shoelaces
follow celluloid
 roadmap of Scotland which drips and has
bronze forming around me like a salad the air
I forgot in the sea-enclosing bottle, fluorescent to the smell

FOUR GREAT SONGS

when

xx

lay down

wherein my fate good morning kisses

"caramba, yes?" your . . . the tumultuous rags

my foot

my hat

your . . . the crumplings of an evening

put forward as ice was

ah trolley!

There the dusk kept up its conversion

throughout the night and, as it was un-

disturbed by the passing parades of tor-

ches, lifted its ear

the except

our still-life yearnings allow tunes

to the far suburbs

Oh cities! him your (they went off)

lost and scraped achoo!

achoo! achoo!

hiding there

YOU AND ME

pasting over the rim of an inferior mountain

 lulling barks

 at night when everything seems

 when they had put unending as if a noose

pin on my foot him in the truck

for a walk about placing feathers the fireplace

 in his path

over there I said we can buy them over there in any

 teasing life

 he took a long drink and looked into the muzzle

 I said there you were beans And the new diesel

 how awful ourselves became

 when have I do about it

tired if you hit me again an old banner

the aerial dupes illustrating

after predicting a wet lovely weekend

 for a galoshes

 told you

a defeat on something cold some more radiator

 neck

 crawling along I was standing

 seater by the wax before

taste of sand his old

 in your back, pal"

 hair in

 pop elevator try the nope look

 on the stupid old relaxing tree

 what is lurch

announced it (meaning you) was missing
followed by the report of a cold
push from Canada in which I was caught
 turning onto Lexington

 or burp
 with paper hats on the 24-foot
never another type of horror those spots of grass on his pants
I was working my fingers on the sea which never was blue

 gasping shells—
 now the reason is "Look it up on the knife

 mix up thicker every
 June on the docks
 is what they sang while behind me I heard
 a sleeve in the bushes
 when I named you me
 daily

CAROLINAS

Making out the flurried emblems from afar,
so bright the fastest runners, though coming
to naught, April, screws, imbecility,
harrow in the napes as "Blow, Winds, and crack your cheeks"
as one spits out wads of moss. The metal braces bend,
knowing more later,
and rivets regrets I'm too bad the spring
knocking at your jambs is eight leagues.
But we drink our drafts and think,
each deaf to seasonal language.

Ah world don't sit too neatly gas-like in a dent!

Sleeve painted with dew fake hills
bricks blinds cracks
elephantiasis departure his dying breath
and pay grass her splendiferous breasts
decades shuddering to tell
would distemper jaundice her keepsake disclose
or the hard papers, we have our woes
 we have our woes
Then the jets took off
air in my hands plain
the nightly reports,
 tempers

Out There

1962–1972

IVESIANA

When it sank it thundered.
So it's dark, dark and lonely.
In winter, when the weather goes down,
You had better come closer to hear her sing,
For to miss it is ice.
You age in oceans of lint.
Putting everything at your disposal,
It will do no worse.
A snake in the grass, yes

Lucinda could be a good girl, everybody said,
But the evergreens fell, and
What could it mean to her, she
Who was nearly perfect? David had amnesia.
Would the children get out of it,
And then gracefully?
Mr. Reiger took it hard, the boys
Stuttering, learning their own tongues.
His only concern in the world makes him dangerous
Yet inviting. He speaks
The pliant truths. Food stuffs. Rents.

And wrote *Willow Ways:*
"Lucinda Lewis Prescott, born of a nerve
In the far country, taught them all:
Four presidents and a rodeo champion!
She has a perfect record,
The clouds are in accord. But the Ford
That drives her to the station drives
An old ache from her flesh.
Oh where will Lucinda Lewis Prescott find
Her well-deserved rest?"

In the pines, the bedclothes think the ocean
A swell dish corporation illuminate midriffs.
But you are so lonely, a single footprint.
Just four months ago for a start I thought . . .
Then it became like crystal
And exploded in our ears.
Mr. Reiger nodded and sighed.
We moved on.
"I could cover you with a Rangoon blanket
But you wouldn't stay. You always want
To be boss." All at once she knew.

When Napoleon's armies headed home,
The hemisphere settled like a broken shoe.
The goodness of this lady and her sons
Make us thirsty for the battle,
But we have no guns, our defenses
Are out of order, so we retreat,
But will return to place a loaf of bread
Upon this spot, so we won't be forgotten!

"Lady, our defense,
Make the willows safe for birds;
Furnish the air from which we'll drink
The goodness of your words."

I will put my hand on your knee.
I feel I am at the service of history.
Life and Opinions.
The leaves.
The schoolgirl drops the clover
And dust covers it. The sun. The moon.
You were bred to be an example.
A rectangle encloses you.
The library burns.
We stopped for a drink
And stayed a year.

SURABAYA

Are you coming or going? The opening
 pages of a scream may thin your blood
but you are a champion of equidistant parts
 the spreading eagle of death
 would you like to die in my arms
 don't worry I will die too you
 will never be alone but then
 and then I take off your hat
 to look a glistening cobra in the eye
grand the destroyers
 are shuddering in the Caribbean
you wouldn't vote a lover of yours
 into Congress would you?
 You would die first wouldn't you?
Later history will praise you
 for being succinct

EAST END

Sometimes I think it's here too,
 which is to say the joy your dress
 drags in with it.
 To go from that to the nearest consolation
 is enough to tear my soul apart.

 So stay.
 The mystery has been proven.

SLIPPERY WHEN WET

For every ticking pipe there's an "Odi et Amo."
Would the quintuplets be reckoned more chaste
In the perfect glass of dirt, our admirer?

He takes lozenges to bed and would be a weird swan
If only the seasons would allow him change.
Here in the garage a feather
Is growing up. Could they have but put buttresses
At the back of the spongy globe to name it,
Or merely as a dumb addition—for glamour perhaps?

The barometer says we're going to get thicker and louder.
He muses on his heels.
If one were always to make sparks with a wave
Of thought, one would be on wheels, eh?
It gets darker.
Here come the twins.

BLIND GERONIMO

"The flowers in this light are beautiful," I said,
"and different from the scorched-earth policies of recent artifact."

 This was a game of odds-and-evens for handling the new,
 the radio tubes blazing where you put the laughter.
"Otherworldly" was your argument,
 but the kitchen laughed too, so knowledgeable
 that happy contestant of sour dour pretensions
 to zombiehood, putting it all back
 for a while into caring, or full, like
 some bloke's got cancer from simple cause.
 It's only the stolen hour that delights you,
 and over, driving to the country,
 taking on more than you can handle.

So those old habits still bear watching.
The lights are on the blink again.
Children and dogs carry on in your mind,
though tomorrow they too will disappear,
yawning through the backyard and appointments and rain.
Time to bring my own complaints to the fore,
as if you had always known it would turn out that way.

THURSDAY'S NEWS

It's a socket—I don't know how,
but you soon learn to count millions into that province;
they roar and change, and that's all,
as if the way the least likely affection
might tap the unsuspecting on the shoulder
and remorse for thoughtlessness usher in.
Your painful cause be this morning's
birdbath. And here the blues match up.

You see it's wonderful how each function betrays the other—
meet yearning raining through a yawn—
so the fool knows his mother's voice
from the first syllable, only feeding time
becomes the trustiest ritual,
like a light impatient to shine,
a cathartic experience.

VARIATION

Half-ended melodies are purer.
To no longer perform in broad daylight,
the apple's a radish for it,
the winter chill a living thing.
But take your brother into later learning:
Let the girls who will smell the buried cloves there.

So I am only beginning to learn what I from time to time forget.
But throw away these childish things!

Barney's coffin disappeared,
and luckily you said the right thing
for the sky mentioned for the last time.
The little master of small talk
is really the seducer of your every move,
taking you into his confidence the way a cat his mouse.

And still young Lycidas cannot express himself fully.
And: "Everyone is the same,"
even down to his jockey shorts, *dolce far niente*, as they say.

OUT THERE

for Jasper Johns

 Rain and the thought of rain:
but reality won't make itself over for the fact that you sense something—won't
 in fact wax miraculous,
though it's right—that responsibility belongs to the outer ether whose fragments
 are gummed together
so as to be analyzable only *in toto.* So
the man who cries "Marvelous!" is only human, putting out his sign. But the ether
 doesn't need this sign.
Cloudburst to terrace to drainpipe back alley sewage to river to sea—
 No need, my love, to complain.
 Quieting down.
 Going on inside.

IN THE MEAN

Running water—
it makes you think of all you didn't do
but not regret it, no, *de ma jeunesse.*
You didn't know I was the President
of a great cloud of falling bricks, did you?
Zoom. Bent. The bare stalk of the corn tree plant
of October thirty-one, of November one, November two . . .
But here's my bath—I've got to take it.
While the house burns down.
Anita is my name—what a pretty name!
What else do you remember?

I was one . . .

SOUND FROM LEOPARDI

To the me of my own making, seeing I am here,
I'd speak a gesture sudden and precise
to show time's inconsiderateness where
to head in, and Death, that busboy,
his vanity of speed.
But always here and before me,
the rude lullaby: "Sleep, Mighty Mouth, sleep and die."

And I would like to leave,
or bring other words and worlds miles closer
as a wakeful company, and out of plain talk spin
Truth and Falsehood, the greatest weapons in the world.

BYZANTINE

And if I tell you good for the going
 What good's the longing after you?

Bill spoke like that, in defense of
Persuasion against the inkings-in
Of Scandinavian malaise. A crisis
Of the handwritten law: Beauty above all,
Against Existence, Beauty's friend, at ease
With Death. So he continued many days
And slept in her cruel reply.

He admired her utter gall.

From Stockholm southward I tested her,
And ended up with not much more
Than the Mediterranean blight:
Sauntering in Nice, I thought I heard
Platonic gangs of fish, all
Jabbering about the Soul, my soul.

So, at thirty, having planned
This perfect strategy: a bland
Telepathy between events, good times over too soon . . .

DARK CLOUDY SKY

Dark cloudy sky
Rain expected
Ceiling low
Barometer falling
Wind at ten miles an hour
High humidity
Muggy

White cloud billowy
A nip
Zero chance of rain
Barometer rising
You can see for miles
Air crisp and fair
A dry day
Sun
But cold

PERFECT WORK

Let's say I give this everything I've got.

What would I have left?

Why, if I followed through on such a promise,
I might end up the cause of my own death!

Who would want to be as silly as that?

Or, say, at least, not that, but that I'd be to some extent
maimed for life.

Life, my love, is that something I would want to do to you?
And Death, is that the way I would want to meet you, either?

Let's not be foolish:
A man sets out to do something. It could be anything.
He takes a bath.
That man loves his bath. He takes one every day, sometimes
twice a day. Some days he even thinks of spending the entire day
in the bathtub—Oh, it would be nice!

He gives himself utterly to that bath.

This man does not want simply to get clean, though that is a consideration: He
could take a shower and get even cleaner! He could take a steam bath or a sauna
to purify his pores. He could even, though it might mean traveling a great
distance, go to a spa and take the waters, that is, drink and soak himself in some
extremely health-giving fluid, which contains sulfur or some other chemical
compound or, at any rate, not the fluorides and rust often found in his home-town
water, the sometimes poisonous stuff in which he daily bathes. No matter! He is
a bath addict.

Behind locked doors, he and other addicts in other rooms prepare and take their fixes, with or without the slightest sense of illegality, or of perhaps forbidden thrill.

(In childhood, this might be otherwise. The introduction to bathing of the infant by the parent might result in screaming, and the infant, in his fear of this procedure to which the parent-adult is already firmly addicted, might try to devise ways of avoiding the sometimes all-too-regular inundation. But, with the years, as far as these old folks are concerned, he learns. He goes his own way to his bath, no longer having to be picked-up, dumped, poked and pushed about and splashed upon, no more that same foam in the terror-stricken eyes, no more of this rape, including the whole business of being the only naked person in a room, and a very small room at that!)

Shamelessly then, and undisturbed, with only the half-hearted purpose of getting as clean as he can, this man takes his own bath. Without thinking too much about it, he wants and so pursues the feeling that his bath affords. Bathing: the man and his bath, a relationship, a simultaneity, and eventually, a singularity.

He moves *in* the water? No, the *bathing* moves. This is the sheer joy of it.

The bathing includes: bath, the bath that has been run (we shall leave out whomever ran it, or say the man is a bachelor and not particularly affluent and so he runs his bath himself), the bath water, and its location in the bathtub in the bathroom (where all is in constant readiness); then, bath soap, bath sponge (or some cloth that's used in the bath), bath oil (or bath salt, whichever or both), perhaps a bath brush or "back brush" so-called, which, during bathing, allows for the thorough bathing of hard-to-get-at parts . . .

As for the bath mat, bath towel, and bathrobe they come later, as does the after-bath cream or lotion (rightly called "friction" by the French).

And then, of course, the man: the bathing man is a Bath Man.

He turns to the right, having entered from the left, his left arm crossing over, hand extended to get the soap, the size of a miniature football (some souvenir?)

or brick. As he turns, so does the bathing . . . this is a faulty description, because there is, in fact no turning man "and" turning bathing but only, then, the turning bathing (though not necessarily in the same direction turning), of which this man is a part.

He turns back—the same thing again.

Now the bathing is complete and gets completer as it goes. Turns and counterturns and leanings to and fro, front and back. (Perhaps this bathing man is a singer too, and he sings in his tub—much perhaps again as his parent-adult sang as she bathed him in order to quiet him in his anxiety and terror—but probably he sings a much more raucous song, or one, at any rate, that few infants would understand—a song like "Anchors Aweigh" maybe or "Going to Kansas City" or "Melancholy Baby," a song then of adventure or love or both.) Now he is really taking his bath!

An easy give-and-take, you say? Yes, insofar as the man can be said to be "bathed" when bathing is completest. But this isn't yet the case.

Now, the man, you agreed, gives himself utterly to this bath, so it is that he is truly bathing. But mightn't you ask what it is he's thinking, and, given the thinking, what, more precisely, it is he's feeling? That, of course, we cannot know, because this is only an imaginary man who's come on the scene only to satisfy our desire for knowledge of what it is he's doing. But if I were that man, or if you were, and puzzled and distraught by thoughts of life and death (to which the song he sings might, however indirectly, still relate), and puzzled and distraught by such thoughts while bathing,

would either of us, lost in the bathos of our self-concern, think to give himself to such complete conclusion as to combine his thinking and his bathing (again utterly) and ever so completely drown?

REBECCA CUTLET

Such a flow of language!
She moves in a strange world,
essentially legitimate,
or what she gambles he tosses
into the drink with not
so much as a word, and butter
reduces to fat. He takes a chance
that this "revisionism" contends up the pitfalls.

There is a house somebody-or-other and this man in it.
Without being completely satisfactory, this is all
I can let you in on, except to say that "G,"
being the sound of two rear molars and the tongue
pressed hard against the outlet, is not to be found
in the first hundred-or-so pages.
You don't mind and anyway
it is only after this that the tricks fade
away into indestructible charm, the least
common denominator of what you took this dive for in the first place.

Follow her through her mind
as you would through a rich moist shaft
that is caving in, but at
the other end of which, where you see her
hopping up and down frantically,
there is sunlight, many photographs and some text.

BOOSTER

You go down to go up.
In theory, this is fine.
But the odds are the plane falling through the sky at what
miraculous rate!
will never see that sky again—it flaps to ground.
What ensues is too horrible to relate.
But suppose
you stopped the picture at just that instant—
two miles up!
The silver bird caught in delicate half-turn,
something like a swan-dive with a twist.
You can't see, no matter how you magnify it,
the faces of the passengers
in flight;
close as you can get, they're just a series of blurs,
slightly "off" details within
this beautiful sight.

LEVANTINE

for Les Levine

Six knobs,
four in heaven,
makes ten.

STANKY

A simple weight attached
and a circle raised alone
(no strings)
to a great height.
Then let fall.
There is nothing missing,
and the space around is all.

The space you see is all.

NON DIMENTICAR

A breeze.
At sea.
Raindrops.
Striped cloth.
Strands of hair.
Salt.
Watch dial.
Slant of sunlight on metal at dial's edge.
Dune.
Wet pebble.
Driftwood.
Small feet run in sand.
Footprints.
Surf sounds.
A ship.
Another ship.
A boat, small craft.
Light from the boat.
Girl's face.
Smile.
Girl waves.

FACING EAST

Dear
Sparks shoot out———
The endless man receives a speck
What fills a woman up
Can't help it I wish
A medium-size wish
That explodes from tree-lined cup to starry roost
I have a hand in it

Rolling
From that you look at
Back-to-front
Whose clouds band together
Like orgiasts
Looking insanely handsome that's
Something not to be sneered at
A sharply outlined portrait

Of a loathsome portraitist
You do me the honor of skipping
This fragile "smog"
Or else I slip
Into the instant decor that is breaking
An egg in the frying pan
At midnight (moan)
I know in my mind that crackle on the tip

You say pen
However
No it's not that
Edged "D"
The droplet grew

To live back here
In the faultless galaxy
Your "nuh" makes true

As rye whiskey
Down organ whistle *Soledad*
The fog that rolls over the sea
And sticks to the earth
Like a hoop on a stovepipe stick
Bought by a genius student Cleveland
With hair of brickish red
He swims

And is fished out by
A modern miracle pan
Found at the Kerguelen Islands
The people suffused in an edge-
Blip banner
Tourist climbs Eiffel Tower
Little boy
Yellow terrycloth robe fixture

That glows in the spinach
In Starvation Orient
Point d'appui
Jane
This is schmaltz
You know it
and I know it
Where will it all end

Between the hot currents
Eye-slit
For restless wool woof
This is a great city

But you are a farmer nit
Nevertheless
Shake a hand
Zowie

I would rather be
Bowling on a bog than
These apocalyptic
Spectacles his
Hair so choppy is
Double the amount
Of sever glossy terrible green
Increase

This penthouse is my
Sullen wrap
But who am I I ask you
To ask you
Banging
To
Young frog
Helmholtz

Flakes, bales, pellets
In a gentle breeze
That lifts the letter
From its dogie mouth
These are stamps
I have millions of their kind
Yet am bereft
As yon empty

Aching outlet balls
Fizz ahhh!
Mr. Bojangles

Today nothing done
Here is the black pert
The trigger figger
Cot-on-mouth

Back to election
Bingo
Despite
So I sent a
".ain in my .eart"
Smith to forehead
Ay ay muchacha!
(Written "Coolidge")

We ash on the keys
Buffeting
Dog hammer that is
A mongoloid eraser
Ho!
You spin (me) this
Den dot the bye-bye
With spot lotion

Scud
She falls on me
And acted glanced *dans le*
Frigging nightmare gap
It's so easy
Try it
You should try it
You should go right up

The dancing bustle of water
Looks like stormy weather
The mule kicked over

On his way to the ledger
To check on the murder
By means of (shiver)
A toaster
Lined with Alsatian fur

Pins
Of Kid Pilot, Ed.
He unsuspecting had
Connected it
To use it as
He was used
To do
The stoo-

Pnagle how is it
Retyping the same work over again
It's pretty good
It's like writing your works
Only it's a little different
See what I mean?
No not really
I was meaning to ask you
OK let it go

Do I hear
"Jim the Lawnmower"???????
The glove approaches zero
I didn't think you'd break that break that cup
And act so vicious
Generally
Like the disorganized appearance
Of a paranoid baboon

I do in fact
Move convex to a base
That is dancing on your bustle
And at the same time
Arrange a flea circus
Of conversation-unit electrons
Northwest Passage
Up a big sluice

This divides Uncle's wedding cake evenly
Twixt nose and shin
A sudden indentation
Beams
(Now this is about time)
An hourglass drunk
The jockey reverting takes a sauna
His last, I suspect

Last July
But meanwhile that woman I was telling you about
And her rooster
Slurp
That drives the truck through the oil depot
Right-handed Maggie
Front-to-back
That's not Gloucestershire I see

Peering over a trembling sleeve
So what
Present person today absolutely
Requires
You, for instance
Yes, what about you?
We should talk about the future
Bales of it

It is impossible to avoid experiencing
Somehow?
Its tiresome foot is always in the door
Like a sledgehammer made of tinfoil
I have watched them come and go
These futures
Basta!
I've had enough

The wind-up and the pitch
N.G.
But literally
This isn't a test is it?
If so, stay where you are
Vermont midnight East Sheboygan
Herr Barhyte
The dust is pitching in from out

The lung patch
Go, little Son, and get your burger
Daddy gets a bite
America, are you for that?
A resounding yes
The simplest way to lower the temperature
Of an air mass is, as M. de la Palisse would say,
To begin by chilling it . . . Precisely that

But a man who succumbs
What is known as "fit"
A bundle of rags
Shows no mercy its rim
Violette
No there is no peace
Tomorrow is gone
Though it may be said

To be a good listener
Which makes me think how we have talked this night
Incessantly
The match you have been holding in your hand
For twenty-four hours steadily
That too increases my awareness
Jane

THE BICYCLE THIEF

I go see *The Bicycle Thief,*
a long movie directed by Vittorio de Sica,
in which Alfredo Ricci's bike is stolen—
he can't work without his bike—and he
and his son go looking for it.
They look everywhere. They stand in the rain, waiting.
(There are some German monks standing waiting in the rain too.)
Alfredo's wife consults a seer, La Santona, and Ricci
goes himself to see her later; to him she says:
"Either you find your bike now or you will never find it."
He gives her money and leaves.
He finds the thief after chasing an old man.
(The old man will not tell Alfredo anything, but
he does: The thief lives on the Via Valpolicella.)
The thief denies he is the thief.
His friends deny it too, as does his mother
who says: "He's a good boy; his record is clean."
He claims he was not in the "Florida." He has
an epileptic fit, for which his mother has
brought him a pillow. A policeman
assures Alfredo he might as well forget it, he
has no witnesses. Alfredo starts to swing
a piece of wood at the thief's companions but
walks away disgruntled. He and his son
go to eat. He thinks about stealing a bike, but
the man doesn't press charges when he gets it back.
His son is crying.
Alfredo is the Bicycle Thief.
They turn their backs to the cameras.
The picture gets dimmer. The End.
With Margo Margolis.

BLUE IS THE HERO

leading with his chin, though bristling
with military honor, camp and *ora pro nobis*, rolling out
the red carpet of chance on a plea
that you might give others a front-row seat:
Lady, take off your hat. So extra special . . .
Other times, it would be a roof garden
like the one Rauschenberg has,
being no Nebuchadnezzar of the bush,
or, standing on your head,
feeling the earth has "hung" a lawn
and these dogs have come to bite you "where it hurts"—
I wonder if they've really caught the scent,
which is a poor memory in our Symbolist ears
of what it must have been like to read *The Hound
of the Baskervilles* for the first time in 1899
oh truly modern and amused and wrong,
before the world, before the cold
and the dry vermouth and everybody started
wearing sweaters, taking pills. I confess
to a certain yearning in my genes for those trips,
tonics of the drawn shade and rumpled bed,
the Albergo delle Palme in Palermo, instead
of hanging on the curb, learning to love each
latest gem "fantastic!" as the lights go out all over the
Flatiron Building, which leaves the moon, sufficiently
fa so la, and the clouds
disentangle a perfect Mondrian, pure gray,
to which you give nodding assent, somewhat true—
you are that helicopter, primping for the climb
into whose bed of historical certainty? the fuel
streaming down the sides, like fun in the sun, air in the air.

SHEER STRIPS

An OK Sunday
 "folks down at the fountain—
 they're not *our* people"
 damp
the racing season's over
 Saratoga's Broadway's
 nearly empty, sunning
 up;
the big spruce don't seem to mind
 nor the maples
 getting milder
 you
can drive around here and see some great sights
 Skidmore's Texas-style new campus (Texas money encroaching)
 hear Marshall Hampton and his Hamp for Soul Inc. at the
 Golden
Grill ("no broken-bottle fighting, please, or *out*side")
 The Doors on at Performing Arts Center ("oooooo")
 eat good fried chicken at the Chicken Shack
 collect
flies on old wire screens
 mildew on the mansions
 Union Avenue
 and downtown
("zero percent chance of rain")
 kids milling around with McCarthy buttons
 still on, four days after convention
 not so glum—
they shoot the shit at ease on fences
 The Red Barn and
 other folks rocking out the porch at the Rip Van Dam the Adelphi
and congratulations Linda and Doug whoever you are

at the Holiday
 Inn, muggy couples
 everywhere
the ceiling lowers, prices down
 but grass prices up! two joints of soggy
 smoke
and *L'Avventura* slips into focus
 (*"Perche, Anna?"*)
 (cheating—
that was last night) Sunday
 papers Sunday breakfast (always "missed")
 Sunday Brenda Starr hard to come by here
 "settle
for the *New York Enquirer?*"
 well? huh? is it going to be a sun kiss and a hug? uh huh?
 or the burst you've all been waiting for?
 and then what?

BACK IN THE 1960s

I love the way the steps
In Chinese Ballet
Rule out
The use of the thumb
In any but my idea of it
Leap
Beeswax
The sure face of wisdom taking out
A banana sundae
And pushing in your face
Mush-o-Rama

COLD GATES

Absentminded person
fades back and folds
between straight blue sheets
lulled to sleep
by early risers
stepping backwards
through cold gates

CANTO

We walked quietly away
Straight through the mirror
Of uncontrollable pain

IN THE BREEZE
for Susan Burke

Buddhism says it is possible to get your mind together like the wings of a butterfly. It is also possible not to get your mind together and still exist, like a butterfly, but with no wings.

LIGHT IN DARK

Redundant pure
to be with a pleasure
in another light
 like a flash
it's cool here
breezy
light clouds balancing slightly
on your back
raised free
& easy by new flowers' alarming presence
all or nothing so it must be
and is becoming as you see
there's a hand close by
on some grass patting down
ringing spacious anatomy of kisses!
 Partly,
where are your eyes?
Taking time now to love it
we breathe in passing & nothing's gone
if you say it even part way
I'll take it in my heart
to stay with while we're here again today

BRIGHTNESS

for Katie Schneeman

An angel on the line
 you can bet
 she's got your number
cool out & kind of empty feeling (late) inside
 where I am
 let's see . . .
 there's bread
 round
 on the shelf
 to butter you up
but seriously I wouldn't try to do that
 Katie
 you stay
 where everybody wants
 to be
 very pretty head straight
 & soft forward
 it's easy
 on the way home
 to ring the bell & walk right up
 a puzzling brightness
to greet you there
 I didn't
 but now I do

FROM A CHILDHOOD

Apropos of laundry: My mother told me of a friend of hers who washes her fine linen handkerchiefs. Instead of hanging them on a rack to dry, she takes each one and smoothes it out wet on the mirror. Then she leaves them. They dry very quickly, and she is always happy with the result.

DANGEROUS ENEMIES

Larry Fagin and I were calmly walking along. He was humming some march and swinging his stick. Suddenly, as if from nowhere, a dog appeared, then another, and still another—in all about fifteen sheep dogs, who began barking at us. Larry imprudently flung a stone at them and they immediately sprang at us.

They were Kurd sheep dogs, very vicious, and in another moment they would have torn us apart if I had not instinctively pulled Larry down and made him sit beside me on the road. Just because we sat down the dogs stopped barking and springing at us; surrounding us, they also sat down.

TASTES

like warm water
with mint in it

the day's complete awareness
a mutton in your eye

a lesson for the heart
tasting much sweeter

than the workings-out
of disembodied systems

"I'll live before I die"

I have no system
but there is a motor

in this body
take this and listen

rough flakes

going down
like wine

LOVE STORY

The gray ball
goes batty.

SUDDEN FEAR

An old woman
watching me
from her window
 Sudden fear!

 PANIC

 She is
 there
 no more

ENIGMA VARIATIONS

for Jim Carroll

A drip in the bucket
 glass of Red Cheek apple juice
the mere continental drift
 "Did
they really want to come back with us
and if so to do what do you think?"
 the responses of dawn are very gulpy
 a second's deafness
says
 "There's an apple on the table
 it's dawn I die"
Days when the dictates of grimy angels perspire
nothing but sulk fever or
 tooth-on-nail
 I can't quite make it
"Who were they anyway
what did they want
and why didn't they get it?"
 A sunny world full of doodling idiots
 it's because the roof leaks
 it's because the tummy grows
 and the crumped daisies get thrown out—
because they showed up anyhow, those persnickety inchworms,
 tunneling through and on
into the core where it counts but you don't pay

TOPAZ
for George Schneeman

a funny little camera
inner neon
orange jello

high
in circles
smoke screen
by Edgar Allan Poe

petal by petal
stamen by stamen
get some ice
and fix yourself a drink

"Anyone new around here?"
"You bet."
"Who?"
"*You*, Silly!"

passion flower
bare-chested
(new type of aircraft?)

"Sorry, Signor"
(They kiss.)
(See-thru style)
(remote control)

The department-
store-bought flag
lacks stars

Comin' right up!
Rain washes down
dried (dead?) thistledown
revolving edge
fabric

soft and chill
behind glass
black flowers
"lots of luck"

I saw the number 5
a ghoulish speck
to turn
and face you

Embassy Richard
= Hotel Roscoe?
("Don't tell Moscow"???)
and gravely they kiss

You go to the rally
with the landlord.
On the rise:
Ice Island
surrounded by servants
the stars drive thru

What's your
mission in life?
(icecapade of trucks, jeeps,
patrol cars, intense bleeps)

passionate and heavy
oh me oh my

The information value
increases
per person
a sudden urge
for direct contact

revolting development!
(missed the two-footer)
and I will go for a walk in the garden
before the sun goes down

animals in the zoo
human blood medallion
eclipse at 2 a.m.

PULSING

Bands of distracted emotion snap getting wider as daytime colors sink and roll on their sides. White powders smashed tight into regular tabs. It might be time to take one of those, meaning, I guess, "Should I?" So that, doing it, this rainbow is achieved, thin bands in arcs of those very same colors.

NEGATIVE

The door. If you pull it it's heavy; if you push it it's hard. This push-pull contest continues until the restaurant closes and the streets are empty of all but a few passers-by. You are left wondering if just holding it wouldn't involve exactly the same level of force.

VIBRATION SOCIETY

It doesn't matter where I knew her.

We were star-explorers together.

Now it's lost.

Great gobs of devotion make me swallow hard in the soft
blond chair. Into the dragon, no one left out!
Some fool puts trees in front of his house in time to see
it all slip away into illusory sludge. We gather our wits
to save him but it's too late. Your beautiful daughter learns the
hard ways of wave-dwellers. We walk away smiling,
pink in foul sunset.

IN FROM THE EDGE

to Lewis & Phoebe MacAdams

The four balls exert
a tender pressure. White.

Perhaps they are eggs
from an aslant hen

who runs in circles, loves the sun.
And her head is intact, but the bands

strip away and some are
sideways shattered.

Strip the night away:
there is a room somewhere

and one lies down near it—
lives, in fact, just outside.

HOTEL LUX
for Larry Fagin

heavy trenchcoats
beer and pretzels
and sad, sad music
goodbye Munich
hello Orient Express

THE LIVING BRAIN

Let the cats
settle it
themselves.

TRAVELER'S COMPANION

for Joanne Kyger

If you're in a communicative mood, call us up.
Anyway, have a good time and take care. Don't
run out of gas. Don't get arrested. Don't hesitate.
If you're the only one of your friends to get into
Disneyland think that's great and send out your report.
This car's a steal at $200. This is the dessert Phoebe
made. It says "Fare Thee Well." The moldy dresses of
Tijuana whores billow about your ears. (Eyes might be
truer; in any case, remember that what you see is as
true as you see it.) And no sweat. As you get older
you feel cold more. This has been a light winter.
You are a warm person. If you write, stay loose. Use
a good notebook well; it's inspiring and becomes a part
of everything that happens. Many suns and many moons.
The tight squeeze of every moment's passing is upon you,
but you wear it with bright assurance and a certain
mystery. African sunrises are the greatest—and the dawns
ancient Pueblos watch lifting from the prairies to the
Pacific Ocean. When you snap this picture put yourself in
the group of the ultimate picture. Act your part as a
metaphysical figure moving, imagining somehow a God's-eye
view, which must finally be your own, the real one. A
stripped and ready consciousness is a handy item, though
only that. *Buenas tardes, Senora!* You may read less, talk
to yourself more. When I say to myself "You" I mean I think
the other person is listening and reacts. Obey the law.
If you can't be with the one you love love the one you're with.
I'd go with you were my direction other than what it appears:
close but veering and temporarily askew. I'll be back soon.
I'll remember you to all your friends.

ROOTS

The people round off this planet

 in spheres of sharp perfection

 prickly, blithe

 as the jawbone

 of a spiritualist's peevish

 ups and downs.

However, these bubbles

 could care less,

 stuck, I guess,

 in familiar gnawing sleep

 between the lights

 of droning planes

as the people undress

 persuasive and abundant

 inside the lens

 its knowing glance

 forever equals

 the amazing ability to forget

Parts of the Body

1973–1983

A-FRAME

air blue
ocean plain
and glowing
woman turning
man on fire

"THE UNIVERSE REINVENTS ITSELF CEASELESSLY"

Occupational panic in the pygmy forest!

Clamp or weight or camper clutch.

A timekeeper's tiny pencil.

The parts you hide so's it won't get lost.

Song: "I wish I had a rubber band" etc.

No one's really retired—they're all still up.

Still hanging around for someone to say "Keep up the good work."

Misty water: The moon's in neon, almost blue.

The Stork Club is closed.

Motivation: Harder than light.

In another dimension, there is no applause.

There are no "moves."

Sources are scrambled, likewise the audience.

Warmer-uppers for other endeavors.

A sense of ceremony: All you got.

Never mind the picture—is the frame crooked?

Paint's a joy to talk of. "Different schools," says Paul.

The company sends out postcards that ask if what you ordered is what you really want.

Always the center of my own attraction.

"Scholars are silent on the subject of light."

ELECTION DAY FOG

the perfect roundness (halo?)
and density of headlights
coming from behind
as I walk up hill
heading towards a house
where warmth may freely spread
its muted grace notes
like pork chops
cooking
it's been a short day
just the right number
of decisions
two
"everything else
has everything else"
says the light
of another stripe
it looks like
that one is going
up in smoke
meanwhile
the past is calling
it all comes back
more or less amusing
like the anatomy of melancholy
a studied look
into the not-too-distant
winning
flame

MAZURKI

Going
Thirsty
Sidelong
Plus
Duffle
Longer
Modish
Plugged
Ticklish
Simple
Hopeful
Double
Grounded
Slept-in
Sure
Uncertain
Glazed
Familiar
Hung
Deliberate
English
Tonal
Garbed
Terrific
Even
Undiminished
Plural
Anecdotal
Laid
Friendly
Shot
Decided

Torn
Rabid
Crazy
Little
Tops

LINES FROM 1962

Classicism! Telephonitis! Boss Sex!

I sat watching an alp

Do you want it? You want it, no?

Call letters through busted radio

The sudden final adequacy of everything

Like the hummingbird's point

Old pond of rust

Old Plain Talk turned the corner

"Large asses are common to large cities"

Paperclip my fancy

I seek to wet you

Cast away! O blue invaders of fiercest charm!

The icebox is the sky

Sleeping with pink angels

Even the gods have disappeared!

I go my speed

I have considered and it is well

Some necessity of "of" being truly present

Buildings come down to you from miles

Loafing under time's asbestos

Of doubt which one always understands

I think of many when my pants go off

"Huffy" like that

As if a minor murder had been accomplished

Hiatus between applause and general conversation

Go, song puddle, into suburban bliss

Skin mirrors, nerve ends of dumb eclipse

Of inner life the wherewithal

"He is very inspiring like a truss!"

FOR ROBERT SMITHSON

shortage

a promissory note

struck

while skidding

can't you feel

those shuffling feet

brain waves

undermining

cliffs of thought

follow up . . .

don't remember

terrific blades

on balls of feet

solar shapeless mass

a mental habit like

a religious pursuit

that grew

they are beautiful, right?

but I am no less alive

WAKE-UP CALL

Opposites attract

but comparisons rebound horribly

in the steady glare

admiration of light

where one is only

different, not so,

too, true

I'd like

a word with you

as against

the reality principle

where nothing's heard

all too

distinctly, where

a door is dark

and you in it do

make expression

I can't fathom

It's that deep

in the heart's thick

rush of mumbles

comprehension

of another nature, not this one

(mine), yours (not that)

what you want

you do it

what I do

is a lover's question

a pleasurable sensation

for now, not yet true

(which is then, not)

you come and go

I stick around

only to move

my way, now, to you

can you feel it now?

THREE

Below the surface, speech changes to sleep.

*

What's that a pair of?
Down across who?
The hose? The wheels? The needle?
Bullseye?

*

Does anyone have the patience?

AN IVES

A man sitting at a piano, singing and talking.
A woman using an electric fan on her hair.

POEM

Like angels, I can only arrive
On the point of your admiration,
And what kind of thing is that
For a grown man?
 But what I really want
Is to do what I can
For nothing in particular,
Letting the black holes rip,
As they may, through your lives,
And golden light on the stones
Just before sundown, anywhere.

DAISIES

Daisies droop and die in a blue bottle, a gift from the 1940s—as, you know, what isn't, oh you born exquisite "on the button" in 1939. A strawberry blond half-reclined on a diving board—Horse Cave, Kentucky, 1973—smiles at the sky whose color blue, in broad daylight, is the same almost as the water reflecting beneath. The dry look of her white one-piece swimsuit, the white trim and green tops of two umbrellas in full bloom at poolside, the smile of the big dolphin as he leaps from the deep end to pop a cork, pleased expression of the afternoon sun as it swallows your story whole.

MOTHER'S MOTHER

a photograph of

my mother's mother

aged about 22

delicate oval face

cocked to one side

her light-colored hair

tied back in a kind of bun

bright steady eyes

on the back she wrote:

"Your little wife Helen

Dec. 3, 1883

In summer or winter weather

Happiness means to be together"

then

"Married to Clay Lambert

Aug. 9, 1883

Photo taken Dec. 1883"

then

"Your mother

When she was young—"

CNIDUS, AUGUST 4TH

for Larry Kearney

I put the candy in your hand and returned to my bee-watching. Stamina could use tempo as a near-moral qualification. Pleasant buzz, frightful sting. The *melteme*, bad wind, that forced him to travel the lower coast of Turkey—Lycia, Anatolia, Castellorizzo—instead of the better-mythologized islands of Greece. Arcana accessible via salt marsh. And that's where Saint Nicholas was born. "Me curator!" with a hip of 0.38 so's you don't take the pictures, tesselated, from the floor. The door got repaired by adding to it. What he took to be the sea as the overview of the Delphic oracle was an olive grove—*groves*, really, sea-green, extending the slope to the real sea a few miles out. "Wuz ya ever bit by a dead bee?" "Did you get my rubber gloves?" The oracle put two dollars' worth of regular in the Volkswagen and spun off, mildly.

My voices always tell me when it's time to move, and where.

CAMERA READY, LIKE A DREAM

for Alice Notley

Pasting pieces of paper together
hour after hour
isn't silly or boring as you might tend to think.
Now it just so happens I haven't a thought in my head,
and the alternative "modes" lately have come pretty slim,
if at all; but there's this that needs doing
so I hunker down.
The glue spreads evenly in the faded grey light—
mid-afternoon of rainy March, wind outside kicking those trees to smithereens,
 studio stove going full blast—
all adhering to the laws of supply and gravity somewhat
sweetly mysterious as the carriage ("poise") of the woman
behind the words on paper "cummerbund" "Lesbian" "Jello"
"etc." or for that matter of her typewriter, considering the next
word in a series
and trying to keep from flying off the handle . . .
No, the words stay put, like dreams, as the rest, including us,
moves along, dreaming, um, "wherever you are."
It isn't silly and it won't be sad anymore than a
raindrop bending a sunbeam (squelch)
into a sudden, more complicated message
or the sun itself
moving down an extra inch
to shower last vestiges of brilliance
to smooth the wrinkles on the edge of night.

POEM

cutting brush with a machete left
eye white cornea gets poked by twig
that was haste now abrasion seen
by doc who treats
eye-patch on and codeine in
codeine trips the psyche
home to daybed stretch
sentences that might be catchy slip
behind slow swirls magenta green
left eye watches patched
sea sky flakes magenta green
bird-size fruit flies slice
hotdog dinner right eye salted
watches sundown then *One Day at a Time*

DOMINO

Mother and son are playing dominoes on the floor
in the cool of a bright late autumn afternoon, upstairs
of the little country house they live in. It is very
intent, like the eucalyptus. Two cats, male and female,
turn and jell on the patchwork Vermont bedspread. This
is Northern California. Every ten minutes or so, one of
the players shouts out "Domino!"

BUBBLES

I was a bathing beauty in *The American Venus*.
My dream of becoming a great dancer: How sweet he was then,
a brilliant, laughing young man of the world, his heart
so tender: "Get married!" I cried, bursting into fresh black
tears. Glittering white sequins: I put no value on my beauty.
Some days I thought I would run away from Hollywood forever—
to Miami to Havana to Palm Beach to Washington, D.C., no less!
Now we are in the air, warriors of the sky, burning the beans
and *Wanted For Murder:* No rehearsal, no retakes:
His actors cry real tears: He wanted Dick to cry too and
Dick was not a spontaneous weeper: Breaking out of his grasp,
I grabbed a shotgun and killed him with dramatic swiftness.
That developed his character: Stars shimmering by beasts
in the black sky: His jaw muscles hunched closer to deliver
his monolog: "You're a lousy actress and your eyes are
too close together." I shoved him away, saying "Are you
trying to make love to me?" "Why not?" he said furiously,
jumping up and backing away to the door to make his exit.
"You go to bed with everyone else—why not me?"

STAR MOTEL

Inside I could hear
a party of people,
the aimless cars
and in the middle distance
inexorable murmurs
of the ice machines.

FAMILIAR MUSIC

A pair of dark blue panties
among hairbrushes.

FIFTH BUSINESS

How can equivocation happen?
Often mistaken as one

Notebook open, notes
interrupt one, "Go fish"

God's first elegy
"Then beauty is nothing but . . . "

Horoscope
says hectic

A bedtime message is
more direct

" . . . tread lightly around
each other's systems"

Always forget *each other*
is spelled as two

Often mistook Eros
for a family story

Jump start in any
tide stays put

P.O. BOX

Old lady peering into her P.O.
box—pink sweater, plaid skirt,
wire-rimmed granny glasses—
muttering "Harry . . . Harry . . . Harry . . . "

PARTS OF THE BODY

Invention covers the surface
the continuous fantastic
in its original form.

Easy to think of
some parts
of the body
as being
extra baggage.

The eye
becomes
concentric.

I form words.

End of the dream
hear myself calling,
"Get out of the doorway!"

A flying ant
you must see
to believe.

Beef and milk—
and cheese is
a part of it.

"Scriabin was a selfish, self-indulgent little man, something of a libertine, who
never encountered real adversity, and who died in 1913 of a boil on his lip."

What you do to your body
for love, and

of course it
gets back at you.

Over the Hill

The moon will
appear
around
the next turn.

Fog involves staring for a long periods.
Sun makes moving plausible.

No Gall Bladder

Deer have no gall bladder.

Phenomenology of Perception

Spit on it
and see
if a bubble
forms—

that's the
only way
I know.

Many a tear has to fall,
not worthlessly,
clean and clear.

PARTS OF THE BODY (2)

Light

Intertidal
Invertebrates
of the
California
Coast

A great
state
of boredom
preceded by
correction

All bottoms are false!

"Old Aches 'n' Pains"
(Luke Appling).

Hope springs to mind
like some post-verbal bugle blast
from the last ditch between
Oslo and Ghent.

Dark Middle

It's that time again
for the stars to be sent up
via dumb waiter.

Mister Motion

It is in the nature of change
to be in your pocket
when you need it.

Tension makes no solution.
Those are the breaks.
You know what I mean.

Fear's perturbation makes men more quiet
until they say, Say no more.

Pleasure on the other hand, recalled
in the singular—
an embarrassment of riches?

a
no
put
in
front
of
anything
it'll
insist

Alex Says

The wider the gaze,
the bigger the image.

Scale, it turns out,
is scope;
we are truly
rounded.

The body takes me out.
Memory is a kind
of accoutrement,

whereby the innards
of the Beast
get all steamed up.

Breathing air and silence deep
One says the secret word for milk

And pizza in a cardboard box
With sausage and anchovies.

Laugh
or
cry.

"A flea in your navel"—
 Yiddish expression meaning
"a mere nothing."

Identity Crisis

Mexico then, Mexico now.

Lemon leaves
wiser than
Groucho Marx.

De-
myst-
if-
ied.

Noli Me Tangere

Ten push-ups
 and day is done.

You Know What Crazy Is?

In the absence of delight,
the mind goes
and fucks itself.

After a Poetry Reading

Nausea is the obvious reaction to hearing a load of shit.

Your Guess Is as Good as a Mayan's

Ends don't meet, they end.
Take what you want,

then give it back
mysteriously altered.

Annus Mirabilis

Funny thing is,
I'm capable.

If the house blew up,
I'd probably
do the right thing.

For Moses

Let him be.
Let him hear the sea.

"Alive with Affection"

Always nice
to see you.

I am glad to
see you well.

BABY'S AWAKE NOW

And now there is the lively sound
Of a panel truck heading due southwest
Along Elm Road, edge of dusk—
The densest light to see to drive by.

The underbrush has brown fringe
And small silent birds.

I saw the rainbow fire.
I saw the need to talk.
I saw a unicorn and a red pony.
And I didn't want any deviled eggs.
I drove home with my collar up.

We're alive. You do alarm me to the fact.
The light is on the window in the air,
And breath comes faster than the hounds
To sanction what remembered, what stuck.

DUCHAMP DREAM

Marcel Duchamp and I are collaborating on a giant wall painting. Duchamp's part in this work consists of a talking portrait of himself—a profile which appears at the center of a brightly colored rectangle on the white wall. Using a long stick to push the colors around, I demonstrate the niceties of the composition to a large audience standing in semicircle around me. "You see," I say, "we (Duchamp and I) are much the same—but mostly at the edges!" Now the right-hand edge of the rectangle explodes in a flashing white light which then "bleeds" into a field of dazzling pellucid orange. The room during this phase of the work has been almost totally in the dark—the only light source being the painting itself—its colors illumined from the inside. Now the room lights up and I am painting the four walls, running back and forth like crazy with my stick. In one corner I draw a huge black gorilla figure and pivoting to face the next long wall, I trace a black line punctuated with a thick gob of paint which sticks out like a fist. I pause, sensing this work is "a great success."

DREAM WITH FRED ASTAIRE

I'm in a large movie theater. I go to the john. Standing at one of the urinals next to me is Fred Astaire. He zips up his pants and says "I'm a loser!" I look deep into his sunglasses, their mirrored lenses, and I say "Oh you're doing alright!" He is visibly moved by the open-hearted and believable way I say this.

ANTI-POEM

dust from windbag clots

days the human brain

scatters mostly

in a dry haze

over hill and sky

and love's colors

hardly distinguishable

from hay fever

sift

thus in a dream

I carry a white bucket

of shit and water

spilling some solid matter

into my vest pocket

and the villain played by Victor Jory

primps

and makes obscene remarks

whereupon I bop his

long bony nose

to a bloody pulp—

a fine moment of anti-philosophy

perhaps

but in the morning you are strange

TO LYNN

The wind is blowing hard, and you walk
through its force to loose this morning's lost bunny
in a field of scrub. It's like everything is adangle
from this earthy grip. You watch patiently. The rabbit runs off.
I watch you. You are bigger than the bushes, and like them, not
to be bowled over, unlike me, by a whim. Head up,
you are fully aware of the clouds, and when there aren't any
you take in a lot of light. You give off a lot of heat in
the form of color. Today you are wearing white.

ALGEBRA

It cost the apartment tenant/owners in the cooperative $3000
per apartment to install automatic self-service elevators for access
to every floor, plus the understanding that the former elevator
men (operators) are not going to be laid off. Now the elevator
men will stand around in the lobby on the ground floor, sorting
mail, answering calls on the house phone, and occasionally
assisting the doormen—say, if the doorman goes to fetch a cab
for one of the tenants or a guest. Also, closed-circuit television
gets installed in every elevator and in the lobby at strategic
points, levels of privacy thereby being insured or diminished,
depending. It is work and ordinary ceremony. But at least one
tenant believes it is unjust. Stunning to think of the men who
taking parts as doormen or elevator operators and likewise the
maintenance crew of handymen made the building their place
of business for, in some cases, as many years from the time I
came to live there as a child to now when I go there as a visitor.
To the three or four who are still there working, greetings. One
I would ask, "Do you still go fishing in Sheepshead Bay?" A
couple of others still maintain their high Irish brogues. Charcoal
grey uniforms with matte black shoes. And there was Eddie
McCaffrey who would say, lifting his fist "One blow from
McCaffrey would do you!" Figure with the A, B and C sides, 36
apartments. My mother lives in 11A. After 37 years, Harold's
well-trimmed pencil-line mustache has somehow managed to
remain permanent jet black.

RED DEVIL

The red devil perched with his sword
a little to the left above the profile of Dante
on the torn square of wrapping paper pinned to the wall
that shows a series of Italian cigar-box labels—
Dante is one of them, as "en Veil" at the tear-edge is another.
Dante wears his customary, slightly pinched, fierce "fuck you"
expression which is not directed at anyone personally, the viewer
but registers inner struggle toward thought and concentration.
The Red Devil was one of a string of Italian restaurants
around Broadway in the theater district circa 1950 where I
used to go for supper with my parents between Sunday movies.
It was my favorite for spaghetti and meatballs
and within easy walking distance of the best theaters—
The Rialto, Strand, Roxie, Paramount, Capitol and Loew's State.
My father had lived and worked in Rome during the '30s,
he so enjoyed speaking Italian with the jovial hefty waiters,
and I would have Chianti mixed with water like a real Italian kid.
By the door and on the front of the menus was a red devil,
the piquant muted red of spaghetti sauce.
One time as we were leaving the place, getting on our coats,
there was a tall stately brunette standing near us,
adjusting her mink wrap. She was sexy, I was 12, I froze
and gawked. Then I noticed my father looking at her too
with a funny light in his eyes. I don't know which way my
mother was looking, but for a split second my father's look
and mine clicked, and he gave me a very knowing glance.
I felt something slip into place.
It was our first shared joke as men.

BURCKHARDT'S NINTH

Paving the drink an elbow couple spans
Like the mantle of first meeting
Or how to make the jazz listen.
The record label on the lunge-stopped truck.
All God's bodies got coats, sheer Easy Street of bundled airs
And the filigrees arc lamps stand for,
The little bleached asides, nudged, padding, wry
Heights like neckwear in a bison's monkish glaze.
Permanent hair pegs in and bites.
Dark as police you trash to find a person dead.
A woman tugs at a kid, heels you could drink,
Twin nurses' rearview pair of backs.
Slab City's blaze flattens, flows
To shadeless: See the lady home.

11:59

A door slams behind the thicket
and in the dark a car motor rumbles.
Another door just thuds.
Somebody must have shut it on their way out.
Like gangbusters the wall-heater fan comes on.
I turn it off and change rooms and put the cats out,
turn off the kitchen lights and go upstairs
to see if you're awake,
start talking.

FOURTH STREET, SAN RAFAEL

There was an old man at the bank today
Standing beside the paying/receiving window while his wife
Cashed a check or made a deposit she wore a light
Blue dress black shoes black hair
Not a sign of white or gray in it
But from the curve her shoulders made a weight sunk
Down to her ankles she was probably of a certain age
Though a few years younger than her husband
Whose ripened aging was no way disguised
A stiff olive drab fishing cap visor above his long bony face
And around his neck he had on one of those thong ties old gents wear
With a metal clasp at the collar and blunt tips at the ends
Loose hung sports jacket and baggy no-color slacks with a belt
He stood talking seriously to her about their money matters
And whenever he wanted to make some special point
He would place his hand firmly on her back and pat or caress it
With such decorum he would be her constant lover any time
Healthy wealthy and wise, and so it seemed,
Stepping up to the adjoining window next in line

TO MARIE COSINDAS

The perfect pose
inundated by reflection
the group portrait groping for exposure
in the apartment forever 1966.
The world turns dolls into urchins
anemones, kelp, private mollusk and arachnid
till the string pops, inflection dings
subsumed
like dandies in shade
their handkerchiefs showing

AFTER YOU

It is a very long walk
over hill and dale
and through the entertainment capitals of the world
to the dump.

DRILL

Fixed breakfast
patch on old shoe

Wild oats stiffen
Foxtails stick

Skylight
Walleye

Webs
Whisked

Scramble
Disperse

Wistful
She's querulous

Hills
A fan belt clouds

I allow as how
I recommend

"A pox on you"
The videotape crew

AFTER 99 COMES 100

Coffee's bad for tai chi chuan
In Southampton we had a smoke alarm
California deems it plausible
To trade grammar for roof tar
The grand rondo for twilight and fog

Corny sentiment and perverted intimation
A stack of weathered magazines
Pet peeves of climate notwithstanding
Could shovel Adirondack or Mono Lake
But what did I bank on then?

This Election Day I tell you
I don't think there's much character in second sight
No matter how numbing post-verbal culture might turn out
Collectively sensible and chthonic
Whatever, but no

My loose foot stumbles overexposed
On the breeze-blasted mesa
A momentous urge in green entangles
Apes and angels, waves
For vocalese

But I want to live in this world
So long as it is just the one
Draped like mounds over an audible rest
That didn't get smashed in the process
When fate was looking

TWO DAYS

1
Today is unsurpassed.
Rain in winter's jowl,
People in ponchos slogging through elephant fog.
"Your phone." "Don't I know it."
And somewhere out there a misplaced fire poker
gathers rust.
Here air, there water.
Formality unbidden spreads edgewise or else
completed a quarter-mile up where vines creep and pry
into bathroom boards. The grass grows.

2
"Glass of retsina at Bill's . . . "
Fake dreams, reddened heat orb.
A word for the day abstains,
a trick mending. Pup gets bumpered, limps away.
Something we could do together, not sure what,
sitting and talking, aimless, adroit.
A day for obstinate, day for construe,
day the color and duration of a line by Jimmy
in the anthology which says "I have nothing to say"
and stays bright and cold.

ON ICE

Doors of jostled vicinity
An eager angle extending in the sky a grey chasm
Tip of island street morning wash
A waking minute pointed to end quote
Squeeze left in diamond-beaded industry
Wedgeful elaborations desist
Shut behind us without saying
White lights from the powder-keg days

SOURCE

for Philip Guston

With thought first the dotted sun
Tantalized youth and darkens words
All the vain, some pure lump at rest
Sucking visible red ripe bone

Ways refuse to pull apart
Destinate melt-line stacks its comprehensive mound
My smokes rise high
Silent face that no less clarifies

Utterable reckon at perception's edge
Words consubstantial home to nothings waiting
Dumbfound here with air and hating
Strange to grow a bush of parts

I who am continues behaves
Like who isn't
Glistering shadow
The fuzzed skylight strikes

Oblique effortless to realize vacant
Building plausible dimension whence
Whole dawns premises exemplary embark

BROOM GENEALOGY

Eventually I learn to distinguish between two kinds of broom plants,
French and Scotch. Every time I take a walk with you I get to ask
one question about plant life, although you say I always forget
the answer next time around so my questions are repetitive like
an absurdist play or catechism. Both French and Scotch broom are
somehow naturally fixed in the mesa ground, the clay and sand and
some real dirt of it, though the Scotch kind you generally find
closer to the cliffs. Plain yellow flowers of the French come in fours,
are aromatic and outnumbered by lighter green fuzzy leaves and
wide flat pods. In the dry summers they crackle in the wind.
I first heard that crackling sound beside the house you were living in
when we first met, the Red House, so-called, on piers, with its
porch and sliding glass doors, next to Martinelli's cow pasture.
Scotch broom is tighter, wirier, darker, all stem, stalk and flower
with no leaf, really broom-like. The Scotch broom flowers are
a flashier yellow, often with a splash of red at the depths and lip.
I thought they were like snapdragons but you said sweet peas.
The French invade every treeless plot, covering along with scrub oak
and coyote bush the undeveloped ("unimproved") lots of the mesa.
We have a wire fence at the rear edge of the backyard planted against
their advance, which can be quick and insidious as Birnam Wood.
Fibrous and dense and hard to clear, a machete is best to hack it with.
You always say you forget the Jewish half of my background. But there
I am with French-Scotch-Irish-Dutch-Russian-Jewish in a backgound
nature, with some Choctaw (Olive) intermarriage on the side. One great-
grandfather of Irish descent seems to have married first one sister then
the other. As for the Jewish part, "the family (after Odessa) lived around
Chicago always. William worked as a tailor for a large firm called
Kuppenheimer for thirty years and was much beloved and a respected man."
The pin is diamond-shaped and edged with pearls. In the center, which is
slightly raised, are the letters Z B T in gold on a black background, running
along the short diagonal. Above the letters a skull and crossbones in white,

and below is the six-pointed star of David in light blue. The colors of the fraternity are light blue, white and gold. Naturally, any background is fleeting, and love today, a forward love, is the only possible fixative that wears well . . . "We had brains enough, or were helpless enough, to stay with the reality of being for each other."

SPACE DREAM

Broken headline column:

> "YOU ARE GO
> ING TO END"

Allen Ginsberg dives through the space hatch.
I watch him from the rim, hear his voice
trail a message "MAN ISSSSSSSSSSSSS"
as he disappears through dot-hood.
The Poets—Anne Waldman, me, "all the poets"—float
in interstellar space, a substance I
can touch, a fine sheen. & then I'm up against the sun,
its soft orange neon glow. "THE SUN," I say, "IS BIG!"
Pause, and a chair sails silent past me into solar radiance.
"CHAIR INTO SUN!" I remark.
 Then we are back on Earth,
speed skating on the silvery
 Power Cones.

YOU SURE DO SOME NICE THINGS

Someone crazy calls me I say "Ah-hah"
I have a jar of ketchup under my right arm
I have no inner life
No time to suffer shortcomings, someone else's
Morning after someone else's going away
Today they went away to stay
Furnishings deranged like looks in instant photographs
One frame we squabble, next we sweetly mend
Cooling heels entwined on a daybed
Seemingly refreshed

YOUNG MANHATTAN

Wild things live in the room
I grew up in, the hum-whee-hum
of low-flying aircraft, their mission in 1951
to blow Manhattan to cinders, off the map

the simple clunk of the elevator cab
at the landing at the end of the long, long hall
shadows creeping every which way along the wall
seem and do, seem and do

COCOA BUTTER

One day in the marketplace is enough for the big blue giant. The price of glory is limitation, he thought, too much. So he steered his magic bus across the vales of fast-talking mist, noting the cocoa-butter veneer of the upper sky and his own eye in the rearview mirror, a dusty blue that shatters.

CARAVAGGIO

The baby goes to bed, and all across the mesa dogs begin barking at strangers who follow the stars on their "appointed rounds," even if those strangers are merely bugs of no particular colors or dimension who in turn continue en route to marvel at the enormous haunches of bold Narcissus as he kneels gazing across inches of heavily pigmented canvas at the image of his surrogate self who is himself all wet.

15½ / 34

Good day, easing off, clouds moved
into every bright distance.
I like ease, how come?
With brushwork stays memory, your nose for a fact
long lured its winter clogs about.
Today cat yawns where yesterday it sneezed.
Right now it yawned. Into deluge reflection
roadside an orange cylinder divulges contents.
"Trashcan, see more at trash."
Solid matters dawn in questions of moment,
curios ample and lax
for ants to convene and pour over.
I didn't buy the book to rhyme or trounce
and now have staved off news, tides, self-delicacy.

MISSING

Who will verify the angles for this street address
or take a capsule of the final tone of truck?

Scared when they don't answer, out past
the hour, and you prepared to play.

Is what we have here a way of stress or trade agreements
materialized off a major phylum's own late sets?

At dinner once my father called me "a pigeon for the Reds,"
and although as always our crystals clinked in kind,

I don't think in Mandarin.
I just wanted to kill my pillow or whatever it was.

Symmetrical fleshapoids dot the pale glass roof.
The big guns robbed milady of her bath.

Amazing, there was no music before or during,
only abscesses of snow.

Wim Wenders takes it to the snow.
The guy with a drink bought it.

The patch denotes sex, but try and mouth
"fuck" sexily when nervous you keep spilling things.

Follow that crab through your usual alternate route.
No clerk can read a fingerfuck for the proper candidate.

A Pittsfield joker runs the human family off the road with his truck.
Maybelline wants to see something pretty before you catch the Owl.

The duck may well return if your friend does.
I need someone to leap out in the dark upstairs.

The poet of particle board sees all veils collapse.
The workers' thought-process exposes the shark face of nations beneath an
 elevator shaft.

Veteran ding-a-lings applaud Earth's curfew from Nirvana Lodge.
Hook those tracers to a newt.

Liberty proposes the private army.
Soundproofings in the Capital, quite a day, "But we don't need *you*."

Meanwhile copper shellfish shatter into rounds
negotiable for time.

Take dire note of my back and woebegone brains in the river.
The swamp's remembrance is a human ramp.

The neighbors' chickens eat our snails.
Time is person, but what but destiny sweeps a room?

An orchid bears the twitch. My need is such.
You can still put a wheel around the far wall.

MISSING (2)

Hopeless and helpless are the significant
 art forms of our age
and the interview
 likewise has its sting.
What is that mothball
 doing in the strawberries?
The boot splashes down
 hell-first to the shin.
The rest goes bouncing with Betty
 along the path to the bank.
I shit not knowing
 what else to be asked
 what might the sudden orders be
 when we bolt for the night.
How prompt.
 The wife allows as how she can't abide
that the goaded message
 falls from the knob,
but the kids say the flying
 remnants look neat,
favored as they are
 by just any transformation.
The law was this putz
 distributed through 50 states.
A few passes with the broom
 and the alphabet is gone.
I can stick with conceit
 or a standard stress
disfigured,
 but give me anytime the keen
vertebrate mindedness
 of Janice Rule.

A FIXTURE

Not ever knowing what she does in the shower,
a frictional sorrow like bedding in dark
feeling brows flex over wireless concerns,
not hers.
A stone in the river you can't move moves you.
And the postholes wobble. Glaze is permanent.

In her partition is the stairway of unhunched love,
a muscular mouth.

MOON PEOPLE

Two blue figures
synchronized to move
toward a blurred point
across the barest space imaginable—
will they make it?

BOLINAS

old buttermilk sky
going to the big city
bye bye

FROM A CHILDHOOD #101

"You think the world
revolves around you."

I do.
Therefore, it does.

Had there been a piano in that room,
I would have studied it.

SLOW CURVE, HAMPTON ROAD

Snow elicits homage
from the honor guard
the outer gourd
the ilks ordained

time to get ready
to go up and get
ready to get
into bed

O rare-at-night felicity
featuring tan cardigan and tube socks

reversible me

"ENTRAINING TO SOUTHAMPTON"

Restorative
I'm trying on this suit of lights
in a seat facing the heavily lidded
man in a seat thinks of the painter Katz
an American Red Cross
green aquarium lights
tinted perspective prospect sufficiency bright

an ability to
change at Babylon

if my breath is scented as of drink
it's because I just took an aspirin

He's gone to sleep
behind the brown sweater
brown hand
pondering the nasal kinks
a staring too-imaginative BOND SAVINGS
(stars)—direct deposit—(stars)
What he saw in the moment he did in a flash
whathesawinthemomenthedidinaflash

after about five hours actually
allowing for chitchat

cigarette clings to the nether lip
facts are veils
"locked in here" (points to heart pocket)

roaring monsters parade between
and never forget it!

Delivery rush alert style sweetheart money

Give us this day: Marjorie, Randa, Joan,
Susan, Sylvie, Valda
 the dainty import gone
missed backgrounds, pasting up others

sky remains, light flares
you would prefer coffee boiled and creation itself
"have at you then!" (Pa & Ma Kettle in Alaska)

newsprint taste of cheese strudel in the awake state
stunning a basketball wind

the coy Brian Boru
the corybantic sissy Benito Mussolini

& none of them are ninnies
none of the following:
THE BLACK JACKET
PARTY
CANOE
UPSIDE DOWN ADA
ELAINE
ROUND HILL
EDWIN AND RUDY
SMILE
ONE FLIGHT UP
THE DANCERS

I'm not so sure about PLACE
(Moses would call it PIGS IN SPACE.)

DON'T KNOCK IT

for Lynn

Over piled leaves by the cement porch
trimmed and shook from a blue rug: hair.
The tangle upwind from where it fell,
where closer a branch makes a hard decision, shock-
definitive.
 Painting's trellis tide,
stemless seamless splurge and spray of
openhanded blue, pink top—
heart's constant labyrinthine shuttle.
Can't resist the way it floods, revvying up
for air: "The flowers are coming!"
A New Yorker's sense of distance: elbow-edged,
you take up a brussels sprout and peel it.
The right white gates span receptive
to your jubilant rush.

BASIS

They index mosaics
Of who they have agreed to meet and operate
Out of webs of future nut-nurtured void
Denigration would be constant
I forgot whom I was speaking to for an instant
And would have been a bad boy
Had there not been brevity and merit in another
As the corner is a quarried conviction
Head bang over walls, chair

LORELEI

"One of the worst sins Dante could think of was to sulk in the sunlight. Those who did he assigned the eternal punishment of wallowing in mud."

"When I met _____ I really had the impression of seeing a saint. My first impulse was to put my head on his shoulder to get protection, which I didn't do."

A corner becomes the top (loaded dice?), and the space inside is fantastic, however dim.

Amid hordes of after-dinner sitters in "pumps," D.H. Lawrence gets up and throws a wet fish on the table.

"Doting is not loving."

Nothing is more perfectly obscure than the trace of intention and no mess.

"Another veering fit."

"Science is absolutely normal."

I really like the whole idea of art.

Because a part caught my eye that I thought I hadn't read, I began reading and read all the way through. Finished, I didn't see what I had missed.

Bad thoughts enter the food chain.

Mobilize versus drift.

You're at the edge of the crowd, trying to see what's happening. You start moving through, towards the center, the event. And everyone turns, adjusts—you're the center. Everyone else is "distracted" by your presence.

Process always leads to something terribly straight. Then it bends and we have shape again.

Think of nothing, they told her, and she did it to perfection.

Silence of a basement in summer, drifting over an impenetrable morass, a lot of throwaway space—

Old lady behind screen door struck by afternoon sun: "Am I in here?"

"I regularly check the landscape in hopes of seeing what I keep reassuring myself is not there."

He groped to express a refined definition of what a man should be to himself. His thought became luminous in that dark field. "I've spent a glorious day in New England," he said.

Only now in my early thirties do I realize the incomprehensible pain of living, the inevitability of death, and the endless need for total illumination, be that as it may.

Those birds aren't the same bird. As long as the body is "experienced," it steals from itself. "I am of space, on time, equal to the place a feeling occurs." The stick figure remains, all of a piece, falling freely through the trees, very like light.

I am afraid I can be of little use to you.

A paralyzed Carol Lynley is booked. Crocker can't believe it!

The heart has reasons, the ego qualms.

Someone told him to shut up but his mind went on.

In 1936, Maxfield Parrish told Associated Press he had painted his very last "girl on a rock."

If the moon were the size of a quarter, the earth would be a nine-foot ball.

"The notion of brain pictures is conceptually dangerous. It is apt to suggest that these supposed pictures are themselves seen with a kind of inner eye—involving another picture, and another eye . . . and so on."

If you want to get somewhere else, try closing your eyes and writing your name with your nose.

Music is never content with anything outside while continually taking in as it goes on ahead. Only music gets through. Everything else waits in nervous contemplation of the door.

True tragedy is never to have appeared.

Primal California Dictum: "I came here with some catching up to do."

"The sky isn't *in* the universe. What does the sky eat? Does the sky drink rain?"

Unfamiliar person, familiar self. People in the theater refer to having found "a second home." Corporate bliss.

Run a pod for president. Faceless growth accumulates dream cells of total vote. Transpersonification of a blimp!

She's wearing pants tonight at the dance.

Anyone can be anything anytime.

"To find out, add connecting lines, dot to dot."

Unconditional surrender is the final solution.

Talk, chatter, prattle, rap, babble, discourse, orate, blurt, hold forth, carry on, natter, mumble, pray.

I snap on the light. The waves roll in in Esperanto. These must be the famous California Irony Mounds!

When everything is turning upside down, try holding on with your feet.

Leave off dedication, enter sobbing.

Time blocks: Tune blocks of time.

The radiogram sat inertly beside the empty fireplace. The gerbil began to walk around the bottom of the big glass jar.

The rate of the draw is proportionate to the speed of the burn, so you need more wood.

"When the heart discharges its load of blood into the arterial tree, it starts a distending wave along the stream of blood already contained within the system, a wave which can be felt in any superficial branch—in the wrist at the base of the thumb, at the temple in front of the ear, or back of the ankle on the inner side of the foot—as a 'pulse.'"

"The bank that served Lord Byron in 1812 serves Joe DiMaggio in 1974."

The world is waiting for the sun to rise.

ON THE HIGH WINDOW

Something to look at next to paint
sow bugs in vodka, purple buns
cyclist's boiling haze lifts
a target to its tilted edge
so spliffs the seens

I see a strange bare tree in the hollow
among the many mossy twists
its branches form a beast
that gnashes at the fog

seen is a point to which
at wonder
stance happens

wishing you a favorable career in Windex
mischeering the hoods

THE POSITION

I have to work harder to maintain being all three persons. I fool around with myself in the fields quite a bit, and come to rest, rooted to the spot, for a long spell. Tending to go to all places, the easy self-flagellatings of prolonged adolescence are not what I'm after. I thought there must be some way I could do something about it. So I got put aside. Simply minded, it has not always been so: You can listen, talk, and so on, but books seem to be signs of their despair. Pale logic notwithstanding, I will be enticed, I am not so rigorous that I cannot be, where you are concerned, though never exactly falling for it. I see you standing in the clear light. I've managed to travel quite far by steady employment on the principles handed me. Absolutely only my compliance has order, a fright wig I wear on the inner sleeve of self-containment. I am not possessed. I don't really have to work for a living. I forget names but their circumstances never. My ears burn to intuit long-distance, sitting in the face of, or dancing excerpted from, as it were, the whole enchilada. I hate commas in the wrong places. They are like dead flowers in poems in life. One hundred years from this day, pow, right in the kisser! The man about town, the family man and the clairvoyant are one. As performance goes, it's fun like TV fun. I can drive this road blindfold.

IF I PRAY TO ANYONE IT IS TO YOU

If I pray to anyone it is to you.
You make a U-turn and are immediately apprehended
By the power vested in me and taken away from you
Because you are minus identity at this moment
Where you linger
In a bad frame of mind
Like some weather on earth
Perpetually stained, and it looks like home.

So borrow a shiny pen
From the highway patrol
And see the boats, instant pairs
That idle steadily
On fortuitous tides.
A grey caulk-expanse for hammers,
As a lady takes a doughnut from a car trunk.

You never know what lands to the eye,
Seeing air stir water visibly.
But water comes to hide it.
Just a mole's margin of sand in any case.
And the nib flows.

CHALOFF

In an instant the world seems fairly made of wood.
Balsa wood, and air. And song consists in passing
nothings around on a deck. The Pacific Ocean rests
upon a peak, and Boston is a bay. Honey dumps the flood,
burying the furlong granite ear. A multi-lunged, galumphing
chain of event stirs and stows the static—
mops, churns, hooks, and levels out.
Downstairs smells of polish remover.
In early autumn a butterfly kisses the goof.
He is able: "I once knew how to do this."

Motion was the first miracle,
followed by a bird act.
While it shines on the pointed hush's shameless order of mention,
a piano's gravity will see to acquiring a proper knife.
In tingles I catch the blandished coffee's murmur on a string,
hearing sowbugs scamper over flannel sheets.
You must soothe beasts first to be funk.

What's new? Maybe Chaloff wasn't. Anyhow, in Egyptian
Gardens his chorus recalls their dancing like a nut.
Night the one color of a vocalist's shirt
embosses coasters from its incline of a sort,
although Lower Slobovia is no way a state of music.
But such aloof floes make mockery of the continuous present.
Against the nub, the nebulous, his glazed twig
wiffles, woos, and wails,
striding an imported pressure the dew blapped.
Which twig holds night?
Who's only catastrophic?
The world and its cracks?
Wish, occlusion, force,
a practice out of fondest samplings, which fitfully bent beads.

ODE

I

Midnight moonlight mobbed Dante's bridge
Nights you are arduous
to ward off cheap distress
anxiety earned like yesterday's pay
Correction can't dramatize itself
probably shouldn't
January passing maples in a car
provisionally bright alive
and at the controls
wrong, no worries, except
motion prevaricates
there isn't much of it
in the right places
a little of who you are
suspected to involve
If I could I would do so out of excess
not necessarily a bad thing
cue me and I'm on
clue me in and I'm yours
now I'm going to name that tune
suggest a title, indicate
strongest love-and-hate scenario
first sign of spring
first serious encounter
by chance with the rich and strange
Whoever scribbled white markings
on the floor at our feet
was shameless and
lacked character
I'm just peeing in the wind
meaning resilient, dizzy and frayed

rain hammers pearls
on the skylights
in a pair of red rainboots
decalcomania
under ordinarily visible
penises and breasts
One house actually had a barometer
although it never did any work
neither rising nor falling
the steady-as-she-goes
on the surface of the wall in the grand
living room behind the sofa
in a well-polished mahogany frame
Easy does or easy doesn't
Inspirited takes care of fathoms dense
with passing hims and hers
massed around the alcove
"Watch the hook. Beware the hook."
Hemming a summit
pulsing white tusk, sky's maritime dray
"Bub!" my father's voice, wrist bone shivers
dreamed I hopped off a big white truck
Queens Boulevard and lost my gear

2

sunlight fractures the plexiglas
fanning around sturdy trunks and boughs
sly shadows of bush in the yard high noon
cow trails wild thought has mapped
rain sorrow brain sweat and fatigue
eagerness of insane
whomsoever eyes take in and fix
requiring required
coordinated gales of laughter light and love
on the way home from the sleepyheaded doctor's office

a fish that eats

birds that freak in unison

bugs at their labors

do the dirty work

a rapid boil

politesse du coeur

politeness of or from the heart

in the assembled body

assuming the bodily appearance

of a body of two

the small boy rolls some marbles around

on the floor of the house

one gets lost

a pointless story

but suffused

with recognizable colors

that travel far

time is important

making as it does

elbow room for happenings of note

to occupy quasi-permanent niches

in estimable space

probably you knew all this

because something tells us

as is its wont

and the occasional savage trance-like state

of people in the process of singing

being heard

SERENADE

Moon comes up, tide goes out.
Your logic is held together

Like by a headband.
Fronting the Painted Desert,

A recalcitrant ocean pounds.
Houses block or frame the view.

In a hurry always, utterly remote,
You insist or stumble into interest.

Either way, another chance to look,
Not to mention what ordinarily happens.

OCEAN AND GROVE

Popping gravel red bike goes, I walk
Sleek or chunky as trees, lupine throngs repeated
Boater iceplant, foxglove dusk
Mesa grasses ardent backing off an orange van

I got a shirt that fits, two feet to lope over
Looked into a photo and saw the face gaunt going
Not a destruction though, just one long face
Transient fair and pointless in a jittery wind

The cliffs lodged to waves melded hingeless
An edgeward dimming tinge
Glad hums in lunar abutment lace the rim
The smell of fennel is heaven sent

SERIOUS MOMENT

for Nathaniel Dorsky

Fair wifely thigh
sand, wave, puppy dog

all presently within grasp
so like the song

thought Mozart
felt Keats

basic stately
neutral sadness

moment in the populous
hour-long movie line

trees rustled, swayed
stood lit-up

skirting sunk Utopia
on such a day

Start Over

1979–1980

START OVER

1

I sleep late now I am fatigued. I'm over a barrel so roll me. I hitched a ride, lifting a pool table with six other guys. "Working / Do Not Enter." I said that.

Very lean today. Cheese. Does he talk? No, I think he likes me, woof-woof. Pea pills. Two? 1.W / 2.M. Would you care to ref' a game of basketball today? This is juice. Vitt. What's that? Kittycat. What's that? Cow. Show me the donkey. Donkey. Cow. What's that? Cow. Where's the horse? Horsey. Horse. Whee. We had upbringing actually, except North and South. "And in the meat the snow." Beverage colors. Unplug jaws. Sure you're not taking too big a chance? When do you think you'll start? Thursday next.

Do you have an upstairs? Valentine's Day. Glue Flowers. Would you like to make a flower? Be made a flower. A baddy daddy. Why don't you color it too? Mine won't work. Color it two. Go put. Here's one for you. Pretty job. Not off hand. Huh. Hi, Rosie. Wanna color? Do some gluein'?

I worry about them. They're trying to cope. I like Ivory too. My condolences. Congrats for a job finely done. Shall we start the picnic parade? Knock it off. I mean it. Getting yourself all excited. You've changed. You're different. I'm not going to spend the rest of my life on my hands and knees. It's not as good as the book. Tiredest of all is when I think what I have not done. One thing I am really tired of is "whatever's convenient."

Redesign, more a rebuild. Run-off. Additional catchments chamber. Run off at Louise Lasser. Could be goldfish. I shift to change the murk. I have to take my hand away from my mouth. I catch you at it. I write Big Band. Know myself like a book and that's why I can't decide what to read next. Texts we've met. I don't stand for the wrong words. The top of the chain words. However I will you say don't, no money. From Stendhal *Love* to *Northern Mists* a twist of the neck. Scratchless cheek. Snow Lake. Thumb on trim edge, other thumb gripping lip. My own excited talk. There are no non-verbal experiences. Results not interested at age two. This business still isn't clear to me. Can writing be taught? TV news is just specialized talk. The gems are kept under lock and key. The key part of the lock fits right in, pumping closure, little black hats.

The blahs. When you come to know an absolute condition you are probably past it.

What's that you spilled on your shirt? Mnh, Toothpaste. A town called Commack, a store called Bohack. Don't make him sit back there in the guise of the topic. The kettle rocks, strange to say. How come "is"es don't exist? Except there's no other word to space it or an apostrophe seems too slur? Asparagus, garlic sausage, hash browns. During *Pomp and Circumstance* the Champ keeps a straight face. Only a pygmy can kill an elephant.

Here is what I did with my body one day. I go hunting words in series or My Prayer. Back to base. Jollities enlivened the February superstructure. Kinds of energy get swapped despite domestic superstrictures. What is life together, something in the eye?

"You certainly make civilization look silly," says Joel McCrea. Moses sucks grapefruit juice from a baby bottle I turn off the light yellow pajamas over them a pink zip-up suit across my lap head in the crook now rubbing his eyes taking the bottle from his mouth extending it towards my right arm lift and lower him slowly in onto bed "Nigh', nigh'" he sighs, I start for the door. Trundle-bundle, the wardrobe of.

Katie knits in Heaven. It's Arthur Okamura's birthday. I'll have to blast those walls all by myself. Puffball slammed foul. Nerf. Stone cold egg. Bach Unaccompanied Cello Suite Number Six. Binder. Marchsteria. Spell does. Comes the day eggs is writing by hand in a book, a novel, and hidden however differently shaped, it seemed that here for practical purposes, for feeling fact, the shapes of the author's single self. But who is the author of that thought? "You won't feel elated when you finish that book." True enough, it is perfectly dreadful and hence exalting. Inside the dome of total recall. Baby strangles cat. Bach Unaccompanied Cello Suite Number Five. A pin-up with no tack. Door opens out zooms kid. An entire new set of particles is acquired. The dime kept spinning, the key at bar's length. Mose shreds everything she wrote for three years running. Thrum, sprightly bass. Time is school so it's detention for you. Stay after. The doctor has to drive some distance. Upper New Yorican streets. (Dusk scene of other dreams.)

The boys are out by the macramé. Boy, is he dumb. How'd you get to be so smart, shoot with my hat? Fight between the cow and giraffe. We need this like blue coat hanger. OK, a goat, bah! He's tied up dead. You don't need two

beds, cigagoo, cigagoo, slow. We need a puzzle. I don't like you, truck, side go. I want to help you cook, I'll start it for you, how do you like it, it's done. Saywong, are you listening to Sesame Street? Hammer, I'll help you. Put a dot on your tomato, put a dot on your grapes. Krystal, luck, baby the truck.

Dry wash, slow burn. (Define each thing by ingredients times use.) Sundown Jersey flats of *Lust for Ecstasy*, Eakins's kids diving under Brooklyn Bridge. Wild radish flowers Joe said let stay. Damon Runyon strictly from Homer. Mose fingerpaints one shelf Crisco. Bunnyhunch! Which hand is the nothing in? Still something there's the wall to solve the man by lumps along the woodpile sun. Watch your head.

2

Dutch paint clay pipes. A stable margin of slow to no-go crams now old clamshell full of butts. Big downpisser rain of pre-winter natural. Today normally my sinuses would ache. They just hit on another cigarette. No ache in sight and I am not the victim to search for symptoms, regularly checking the landscape in hopes of seeing what I keep reassuring myself is not there. Search me, and the other of gigantic stare pursuing an image presumably in the studio mirror unless naturally you do such work by memory with eyes closed, in which event bypassing the exact outer image marginally in favor of a funny kind of—is it psychological?—replacement. A color plate anyway. Displaced.

A cut above the weather.

" . . . bevy of simpering cuties in a bus."

Sunflower Sam.

First thing got out of bed and moved the chamber pot to catch rain water pouring through the rafters. Then Mose woke and we shared another early morning of insufficient restedness verging on explosive discourtesies. Dagwood grunts. Mose takes a pratfall on the spot of kitchen floor where a pan of flaming olive oil spattered the night before. I keep thinking "mop-up operation" as regards whole days. Backing up a premise, reading the troubles women loving women make of

themselves in boring mock-Irish prose. Too much reminded of the language's protective coloring. Mose pronounces a different name-day for every day of the week. Today being Sunday he pronounces Saturday and later amends that to Monday. I am his Boswell as parenthood furthers constant biographical notice and the distinctions come more various and pronounceable than between personality-bearing and history-starved adults.

"To know a man now is above all to know the element of irrationality in him, the part he is unable to control, which he would like to erase from his own image of himself. In this sense, I do not know General de Gaulle."

Sitting in a chair in the middle of the kitchen, off the instrument. Small dog jumps off the edge of the book, cat to the left of my legs crossed. The cat is now at the door wanting out. Out she gets and another cat enters, brushing past her. Coffee water dribbles into the glass pot with the hourglass figure. The yacht banged into the boat and into the fish and into the soap isle! Wind is a felt presence. Rain takes different diagonal courses down, hatchings like the shadows along Rembrandt's cheek.

Silence that sticks like where the key fits. The cheaper paper cones for coffee refuse to drip properly, fluently, wasting it. Rumbling innards and you go to the store. Small boy can blow a whole pack of gum in an afternoon. The phone rings, stops ringing. That sounds about right.

"Between April and August, Roosevelt, Mussolini and Hitler had died. Churchill had gone, Germany had surrendered, and the atom bomb had exploded at Hiroshima."

Get thee behind me, things that pile up! When there is no schedule and every day has to be invented to find use, then little energy remains to speak, much less to inscribe consciously, of the day itself. So I use sources, she says. Color TV burning the air before your eyes like a thermal mobile, the thin grey line of motion only inward. This one's in black and white: A man and a woman are trapped by a beefy maniac in a big white house. How escape? Pet boa constrictor's no help. "Imagine married life with a paleontologist!" Monster fangs, huge insect eyes—"Dynamite! Quick! The dynamite!" Man and woman climb up out of cavern onto sunny hillside, a fresh breeze blowing, and they look back: "Maybe it never happened!"

It is raining between the pages of a book. It rains on the book. The words, their "right orders," stay in line. The words are all water. The paper vanishes into thin air.

Nice summer weather, hot enough for swimming, long clear afternoons.

Assume, taking the plunge, the first deep person. Dreamy Mallarmé seized beforehand, on ice. All there, nothing there, there there, all I can do to restaple it. Sing the songs I know: Here a chick, there diamonds the branch hatched and then the bristles of other trees on top of them and above those comes sky. Knee-high stove metal sheet cylinder, hole in it burned out. You have to break the bolts. When's nap-time? "Ee-Ay-Eee-Ay—O" he crooned, he croons, he keeps on crooning. We have come like birds to a stable strategy of crooning. Pauses arranged by soup.

Six a.m. the neighbor's dog gets to barking, then house dog in daughter's room joins in with a high yap, yanking me out of unspecified dream. Seconds later the baby starts muttering over bear-cub-dotted bedclothes. Soupy no-sun up, chill Thanksgiving morn in the offing, recalls of nicotine spasms in getting to shuteye some hours previous. Police-kit motorcycle from maternal grandmother rolls over mattress the while, early-in-the-day kid of good cheer. Wife rises growling. Dagwood back into stupor an hour later follows. Before and after, later then now. Breakfast egg, grapefruit, and the end wedge of last night's spinach pie, and make coffee, all in a particular order not like a menu. Brisk bright windows blue sky. A big turkey from Santa Cruz thaws in the sink. Finished a letter and added several P.S.es, sorted through self-important-looking stack of bills and select three to bring bank balance to insignificant $13.80. Other mail can thaw. Bandanna brushes ashes and unspecified grits from the desktop. Cigarette smoke a Tiepolo in the rafters. Yves Klein. Helene Aylon. Inside and out warm sufficient for an open door. The digital clock face flips over 2:12. A door thuds and somewhere overhead a motor putters. No, I'm not dead, I'm remembering to buy a new Bic lighter at the liquor store this afternoon. Til then, wrestle with the standstills, writing with a backhoe, and prospective, make notes on how to proceed with the actual panning. Naturally, the plain nuggets are right here scotch-taped to the bottom of an 8 1/2-by-11 sheet, gravels sucked from riverbed and directed through sluice box ten-foot length bottom covered with carpet to collect fine gold. Blue your pan, says old

prospector, it will hold the gold better. "I tell you this was a great thrill. Enclosed find sample of handpanned gold. Please say hello for me."

I dream dawn on Fifth Avenue NYC. Street sign reads "40" but we're facing the Metropolitan Museum at 80th Street. I walk, turning uptown, on a series of white blocks. They are Rain Altars, on each is inscribed lines from a new poem by T.S. Eliot. This poem is called "The Way." I see soul as a great storage like a present address book. The Dictionary of As If. And Sutter goes berserkers. Heater off now, he's blued, a small plane dangling, buzzing low as if to inspect roof leaks, we got 'em. De Chirico dead, and R.I.P., too, Lennie Tristano. The day going on night, more irksome or more sullen, no longer with us. Live dog among horseflesh. Replays of years drawing to one close. Uncus, Chingachgook. Composure, or so he thinks. "Here's his private number. Be careful."

3
Our dozes met. Lump matins in the glue works. Bound to a ton. Eureka.

"The world is too much fucking with us." Slice of finger with my bread. Continuous taste of the usual Pete Smith Specialty. Bye-bye, Toms. Embraced, they stray.

Whatever exists exists at all. Movies and mountains. The idea of a puppy. It never entered my mind. And which for the child is easier learning, patience or perseverance? My favorite lie: In prison one would get a lot of reading done.

"All day nervous wonderin' what to do . . . mighty repetitious." (Jack Kerouac)

"Enough money to live like people, y'dig."

Find true right. Can you describe clothing directly? Forms of dress . . .

Mean angel. Word sleeping on the yellow stain out of door. Nothing to do in the house. Cat meows, kibble strewn to four corners of a brain wave which locks, ouch, you can sense it. Roseate patternings and the reflection has a flinch center. A coffee stain. The fish died. *Parsegenia* I dream is a book by Turgenev. On the cover of the Everyman edition there's a cameo portrait of a girl, three-quarter face possibly a Vermeer. "Look for this book in London," I tell myself and wake up thinking "Parthenogenesis."

Amidst
light of bush *en la mesa*. Feel keyed to have made a mess of words. My little dog,
Cuba. Little boy, Mose. Wife and family, matters of life and death. Orange pulp
still clinging to the rind. What traits you acquire and which prove to be of some
constant use. "Performance is simply the latest word for real-time activity." The
car backed and the pipe hit. Write a friend a letter. A friend's house for dinner.
How you like? I like fine. Thank heavens for dots.

October 10th it's Monk's
birthday so luxuriate, hah! October more, shirts, the mist, then heat-wave, then
gets crabby. Dream Norman Bluhm paints a mural in the Bolinas post office.
Norman has been divorced. "She told me the marriage ended eight years ago," he
says. The mural boasts a naked woman foreshortened lying on her back, head
foremost in delineation. I read *The Duplications* drowsily by sunlight in the
backyard.

Mean angel. Moritat. Sudden hungry dog. And eating a brownie on the
stoop I smell oil. "There is no real content to our days, only our wild
imaginations." Embraced, stray . . . Wait, first let me tell you what happened.
Nobody's anything's everyone's mine. My loose tooth. My hammer. My piece of
wood. The records. The keyboard. Everybody's ears. The car is our car. The mail
in my box. Who else knows the combination? Don't hand me that that any's one
though. I don't buy it. Let's call that perfunctory repugnance. Mose says,
"Anybody Holly."

Bloody body and wife and kids. Pushin' yr typewriter, hah?
Bright and cold. Please put my jacket on me so I can go outside and cry. The
grease pencil melted on the cast iron stove side. Glass in there wears out so you
expect it to last until it doesn't that's the lining, and the guy from Woodstock said
the welding wasn't so hot.

Dream is, I'm showing Mick Jagger how to dance in a
bowl of rocks. I wake up hearing "Beast of Burden" between my ears. Another
showbiz Purgatorio rap. At day-care Mose bit Nigel on the arm and it looks like
Susan is offended. Funny, you want real pain to be transformed into a conception
two can share like pleasure "Yeah, let's" or "Yeah, let's not." But that's not in the
bargain. Pain is really special. Think of dreams that entertain the fear of it but
never see through to the hurt. Whereas you can have pleasure clean through and
even speak of it after.

We both like solitude and we both like each other's company. Together we are getting everything but. Fact is, I hate to talk turkey and cannot begin to explain the sorrows *in absentia* that accrue. I take them to be the opposite of my nature and lay no blame for their adhesive inarticulation. My address book is intact. The weight of the world is not sculpture so prefigured is it among the productions of a kid's crayon verve that we who pretend to know it tack it up inside the home, on the inner panels of front doors, reminder of what's in store if one should cross the line, e.g., go to the store, get chewing gum for the major genius.

A whole life is this click we make. Fumbling, pushing ages, hands and feet, brain and penis and address book intact. Ink stains your fingers as you turn the ribbon over looking to chance interpret the letters agglomerated there. I don't think Nicholas and Alexandra should die, no. Yesterday friend's wife had shown him a baby snake. Today he could kiss her ass. Can the job get done and never be televised? Leave the beckoning to us. A furry caterpillar traces lines dividing disks in quarters. Is this how you usually speak to adults? Give the gate a fair shake. I miss my fish. Energy translates a room as if the world were verbal. Seriously. Consider it safe from the whirl. Consider it dead. I recall it is not just you who makes me do this but also static. You flatter, you cajole, you ball it up. It's like there are (there are!) flies all across this page.

I am rubbing your shoulders by the kitchen sink when the water meter man appears, gesturing with his clipboard for someone to go move the car.

4

The weather in Ruysdael or Trenton. *The Great Trade Route*. Sun shines five miles inland in another direction. Guys on a cherry picker trim the overhanging cypress/eucalyptus branches and the wires hum. Indian Joe with his ears to the ground. Power grader rattles over new road. Pushing on forty. People lugging groceries home. They say money is hard to come by. He shows them how easily had it is, walking the length of the bar, sweeping all loose change into his hand as he goes, keeps going, pocketing it, out the swinging doors.

Regulating my mind like this in solitude—you'll never know if it's slipped—and the parallel world of people, "the people here . . . " Pleasant thought that some

instinct's intact. "Human voices wake us and we drown." Imagine the looks I give out of *that world* as they go by in cars. And downtown Bolinas, guy tacking up Scowley's menu on the Market bulletin board, a few "Happy Hour" customers visible through the doorway of the Bar. A big blue Cadillac. The Shop dark, remodeling progresses. Big cypress on the hillside, Francisco Mesa—where, some years previous, a small blue pea-size beauty dot burst mid-skull flooding the sob-circuit. Almost Winter Solstice, days seemingly lengthened in advance anyhow. Another guy tuning the piano in the Community Center. "Everywhere I go I know what's under me." Clara, light, the power or powder of wax, wax the color of angels, an angel's foot. Here air, there water. Eat this sock.

Now I know two kinds of yellow truck. A stack of *New York Times*es tied with frizzy string to be trundled off, back of car, to Henry's Service beside the creek in Stinson Beach. Mrs. Henry renowned for her phone yells, pink house, sons who work the truck— Henry Henry, I once heard, is one—the serious-demeanored cactus beside the perimeter foundation, lots of abandoned might-be-handy stuff in the yard. You leave the bundles of newsprint under an alder tree.

Odds are. These days of being together. The best they have to give. Care and feeding of a bed of roses and the thorns. Bad bed has grains of sand to forestall sleep as caffeine has alertness, sort of, and fatigue, built-in. Significance admiring and respect endowed with qualities nearly in reach you latch onto, existing and unimpeachable as, say, a banana peel lobbed into coyote bush. Do they acknowledge heartaches into the chicken dinner are built? Dogs in throes over a dark bone. A part of two. "Back in the kitchen was what everyone had expressly sat down for." It throws them. Now you talk, dark bone. Rooms within rooms, the buzz of the personal, first star I see tonight.

The dog humps the cat, and the cat is female. I woke and thought of the New Year in pre-Copernican terms. Less character, less pre-bloated. Wired to the writing in the same voice or an adaptation. Whoever today writing in a woman's voice. A mousyness being. Against the grey sky the green trees in middle distance look black. The same but nearer against the black ones look green. Eight jacks and a superball. Thung, thong, thing. I stare through the lightbulb into thicket. Rain goes the windshield wipers, sh-sh. I go to the office, then to the factory, then to the Co-Op, then home

to write. Heavens will not fall. A cruel proposal dating from the clearing 4 p.m. pavement. The duck's breath has played about the shadow of her smile. My, she's beautiful albeit out of reach on the other side of the mountain, to see plainly the advantage she would cozen. Men who drink slap their sides, the motor clicks forward, a sloshing like of beer.

Going about her business in a day, and I'm a busy man. The space heater is turned way up as though it were cold. One hundred things meant mentally for recall are (rip, foist) plastered over. They aren't. I don't see them there, or from here. Idea lingered into recent times, for the rest of my natural life whenever I get back to it. Red trees when the light's below, looking for the edge and oops found. In the diamond pattern I distinguish two shades of gray: one like the empirical blur known to scholars as "California" or "The Original Flake"; the other is like the North Sea of Henry Heine's wild imagination, pure surface maintaining one eternal stranglehold on depths deep down in which sense finds no verbal junction, perfect for watching the sun die.

5

On white paper film speaks, you say hello to yourself in skins. Walking a light print dress on a bike seat wheels, zooms by the tree trunks. Flashing the road past the grove. Address changes outwards, so where'd that go? A shot like a flashback only you keep staring ahead down the pike. "What holds these things together?" "Celluloid." Big butterfly, you blinked. Say maybe the creek ran after her. Fair, crisp, fresh, as in a rhythm section. Let's talk business elsewhere. You are free to guess.

> All this obligato
> He learned to read and listen
> Lifting a chair to hit you
> all in fun

October 18, I dream a big spider tufted with pubic hair. Teasing harmonica in the neighbor's yard scales, stops, says, "See ya!" "Don't forget to wear your boots!" A late-blooming sun flattens near-sides of trees. Quietly then a new voice shrugs "Forget it." How so? Hello—Hello—Hello.

How are you? I am fine. I—am—fine. The floodgates close and behind them the
waters are brimming, a dog salivates. The dog is frozen in this gesture, an icicle
hanging from his chin and a block of cement chiseled into the shape of a bone
between big front canine teeth. Whereupon she says, "I need a new Spring style."
Start over so you begin to see.

For love and money and for George Burns. TV
pink aerial wags towards Orion, the California of the skies. A resolute sense of
scatter. She is at the front door in eggshell ermine a glass of Cold Duck in each
hand. Beads fall between pinecones and mittens. Baby hollers in a field of Ritz.
The trio for evening and fog. The sense of them is Gothic. As a couple they seem
Gothic. There is something chill and stone-hinged Gothic about the two of them.
As people, coming on really Gothic and bizarre. The Gothic way they both live.
Proviso, caveat, why the hell. Cold grapes. I believe that hand from the cloud.

The kids right the bean truck. Piece of mud, a flat over wet ground. A Colorado
flatiron too. High blues and dry whites. Every day's a quake alert or summer
mends its oboe shine. The topping branches grey off, a bug-strewn veil. I'm not
just grousing. Girl in a turquoise swimsuit on the beach looks like my second
cousin Mary El. Pointless feel of looking on without words (or the contrary
sense: "These are my names!"), things in blinders slipping, going through one.
Lift eyes to trees, tops, walking, an obviously scary bliss. Light colors of roses on
a bush, paper trash in someone's front yard. A beaut'. Ineffable's the base.
Remember when a kid they said I had a downcast look, staring on the road a few
steps ahead, supposedly introspective. Here it is since then and how long have I
been doing this? A little rod raised above the gong, a straight blank whole.

I've been sitting
here. There's no you. It's a possibility. The puddles glazed of thin brown ice.
Mose up and goes to nursery school. Nobody's going to touch anything. This
going bearing neutral off a working cliff. So I started concluding. They ask me
and I write a book. I moved in and Jack or Bill said now you have a cabin. A
roomful of haystacks I connive on the bias, hold large inventories and make do.
Kettle, lantern, mouse, a ripple in the ice tray, "I want to be a nurse." Bicameral
denunciations that would sour a Doge. Another 'scape in car apple dawn. There is
death in that sentence. Stars you see on a page blatantly do not remind of night
from land. Likewise, when asked to introduce one to a group or one group to

another, the names all around elude my saying. I want to say "You know *you*, don't you?"

Beer from Holland comes with rubber plugs. The cat moved too fast, the bird caught it. "Daddy, will you wash my butt off in the water?" May 8, Lynn and I get married at the Governor's palace. All set to cook the Nuptial Egg. But there's an extra fee for cooking it on the Governor's hedge, which burns in the process. We decline this optional pleasure, speaking with Mrs. Governor, the nice old lady.

If it rains in his brains the word for grass grows. Green grass water all around and under. Plot of grass, conspiracy to replace a lake. Beside the lake a sick cat will eat grass to grow stronger, more resilient. That is to say, the grass key. Extravagance in his rightful grass. The word for grass relaxes. Throws the magic switch. A man of keys, a man with keys.

6

All birds fly to one tree. All birds go home. It's everywhere, that's something, you can't beat that. Thus does prehistory enter your life. Old dark wood house, white wicker furniture, separate room for stray cats. All you need is scratchpads. Drawn to story alter middle of pose mouth. The sea is loud. I want to say recalcitrant but the sound winds stuck. Instamatic camera dangles from the draftsman's lamp. I like ease, how come? White columns beside the inland sparkling sea. Short and sweet, so a quickie. It goes a long way back, aimed at abutting on the abstract express. In the Aquarium basement we have chilidogs. Wettening cunt on some Australian mountain long walk home in cold spray. Home is not a harbor. Alice is hungry. The dog pees on a sandcastle. Surprise blue indoors. The foghorn bends a blue note. Shower, dress, shave, start cleaning up around the apartment. Acedia in the parking lot of the Surplus Store. Vocalion of Mister Mustard in the surge brown soup. I'll hire out as a flyswatter. Weigh out this chair. A grown-up Archie Comic. You laugh.

> "He's loyal, devoted
> in fact, he's a jewel
> But critical often
> and that's a bit cruel"

A dog dream, large and fluffy. Dream I'm talking with Jimmy about his new book *Other Sides*. Lynn tells me her dream of a red fire truck on the ocean. In front of the truck stands a man wearing silver- or gold-rimmed spectacles holding an empty drawer. Dream I'm writing a story commissioned by *The New Yorker* called "The True Romance of T.S. Eliot" which begins "Samantha ran down the stairs." I dream I tie my tie. Dream my mother is in a hospital in a state of nervous breakdown. She is a young beautiful blond and we fuck. Dream the little white tabs at the edge of the half-filled swimming pool give way each time I try to hold onto one. I wake up thinking "Sink or swim." A Paulding, Ohio, sign reads "Get Right With God." Milky light bulb reflects on milky coffee "001." Whosoever lists the nights it rained. Each has a book and so something to drink. Last night it rained then snowed and this morning rain again, wet snow in patches on the curb of Hampton Road, slush for a saint's day like high school Easter vacations ever commencing with the last packed-in blizzard of the year. Blue-ice Elysium of Central Park, off-white rubber booties of Kim Novak in *The Eddie Duchin Story*. At Eddy's Luncheonette the pickle jar advertises fundraising for The Little Flower Orphanage, burned down. Mose immediately interests himself in the predicament of homeless peers, stares for a moment at the small square sign glued halfway round the pickle jar, then pointing emphatically at the lunch counter, says, "You mean they're going to live *here???*"

Do women think in a clam voice? Does a bear? We've had to have a speech to the desk. An uplift, right push upward, pull back. No sleep to speak of rhythm, and now what I did. Proofread by sting ray, troubles on parade, 4:25 p.m. in Toyland, in disarray, in mileness, a utility field. White cabbage moth on the inside rim of the Big Bird glass with a bright pink wad of Bubble Yum on the bottom.

This is where I get off. Almost midnight. Dogs, dark, double ducky. Welcome to the Wonderful World of Family Living. I drove home with my collar up. In the company of only women, clamshell caught in the blender, sharp and buoyant fellow. Lolls reading *Paradiso*. Scrunch. Peduncle. Scrunch. Tongue pressing roof of the mouth asserts connection. Don't knock it. Don't laugh, that's what you think. The received idea is parent to the old fart. The priest in the pit says, "Everyday life is Hell." "Yes, that's true," I tell him, "but there are transformations." Signs of spring. Piecemeal dither and a fire in the next house. A dim metallic helicopter streaks past roofs

along the shoreline, spotting survivors. The sky smears, the smear clears, now fluffs. To think something benignly simple, to wit: My mother made me breakfast this morning. I sped up and hit a dog. For shame. Attitudinizing don't pay. Nozzle in the shade, the earth and all its Pampers. Livewire kid puts arcane exuberance to the wheel of "Guts! Get it? Guts?!"

Assume the clerk. All this from somewhere I could use, notes mostly as I stir the potatoes or fashion a new zipper from the toes of the sloth. A peck from the supply wagon off Mulholland Drive. Waters of California run up the flag. The sea is loud in its mileness. Vizzi Red Creme Enamel says, "Going out to George's tonight to chew him out?" "Nah." "Mimsy?" "Yeah." "You're wanted on the phone." Six girls on the Long Island Railroad sing a song of their own composition, "Talk Dirty to the Animals." His poems are criticism mostly, coin of the realm. All that centrifugal influence of a stove. But I've been influenced enough all along. From first things first to the final finish. Whose dish night?

7

I was talking figuratively about something real of course. Like, you are a kid and you *are* strong. Small matter that I can whip your ass or Darth Vader won't listen to the supply side of Empire melting. This is such a small room that I lose the extensions. What use is a phone cord if you unhook it? The way money works to pay spleen as I walk uphill with a recognizable later. There are those who gleefully describe a situation as intolerable and then devise strategies that are, at best, intolerable equally. White Shadow wants his brains back. Coalville, Utah, does without a one-way street. The phone booth at the corner gave the only light. Boy, did I need to talk. In the knowledgeable kingdom, things of its stars receding, thin red reeds. Horse feather sunset at Agate Beach. In the garden, putt-putt, hear the light, the signed edition of a concrete step. Things so stark in nature they recede. That nudge tone, phone turned off. Surplus of cognates. To you's a useless trine. I need a whole new deck.

Decision cantilevers on the perpend to a one-way street. Road narrows to one lane which is fast disappearing, classrooms in the deluge. Matriarchal America. What if the house fell in a big dark hole right now? I sat up in bed portending feminine/masculine in mundane paradise. Four birds fly across bar lines, followed by five, four, unaccountable, a flock. But

they're not the same, I mean blameless. My love is not careless, even though it never learns. A small red sore on my wrist seems to be telling time. Air matter water. A bedroom yellow with a Yale lock. Marriage is that basis that mounting eponymous spot was hot. Was hot you? I married a colorist. And honestly she looks to me so clear I get ideas. Can you explain yourself to this life? Inroads of an ocean that never stays put to become its name, slanting flying, state of clutch. Rage chases panic around the bed: "Nothing!" "Shut up!" "Real!"

8

Enthroned in the bookstore, a clerk for the day, thoughts of certain absent ones become group portraits of bodies, faces known a few feet off the floor above eye level. The inner crystal horde light presses, switch thrown, on air detected. Allakazam. Quite a science, so reasoned and factual the angels are. "To have something important materialize is not the point at all." Now only medicines arrive in the tiny thrill-boxes decoder rings once were dispatched in from General Mills. The time is more marked, more repeated than heard. If you ask him he'll tell you and then you'll never know. Electric tin can out of somewhere, Speonk. In a faded code, the paint-removers try to tell Santa's helper the way things work in a people's store. You've got the right idea, Utopia, I grant you a phosphene, I leave you Anna Schmidt's flats, three-chord Persian Gulf or the "Now You Have Pushed Death's Finger Lobe" dream.

To touch only when appropriate. In a staring contest with the cat I am always the first to blink. Would you let your child come home unescorted to an empty house? The yellow machines are shaving back French broom to clear the culverts. And there's a back loader too, the purpose of which isn't clear. Chou-Chou says marriage is unlikely for other than weird. Andrew's gone surfing. I seem to be tottering thematically in the afterlife but that's mere books, music intelligently structured but not (bzz) taken to heart. "We've got a lot of banged-up birds" says a street voice. Luther Burbank invented the nectarine so how much do we really know about Malathion? Do we save *The Life of the Virgin Mary* for Larry in Brooklyn? He is the one that calls her Honey. We all have to get up in the morning. "Honey, I'm leaving now."

If I think long enough soft enough maybe I could say, "Want to jack me off?" Nicotine and caffeine are vasoconstrictors. Fear of empty compares favorably with fear of none

whatsoever. What is fear? An extra corkscrew for the twist-off cap. It's only natural that I save myself to kill the moment before it breaks the skin. Burning paper mirror, nice new smell. Compares curiously with the high-keyed excitation of credible rebuke running on empty five miles from headquarters or thirty seconds over Tokyo. Tenor madness. Snowy moon inside the pinball whale. Alamo *amat*. "God help me," says George C. Scott's Patton in the burning ranks, "I love it so." Same goes for New York. I dream Edwin Denby at Tie City, green sector (green, I'm against green!), Mr. B.-collar conceit, and the ever salubrious Smith Brothers. There is good, better, best, and bad, worse, worst. From bad to worse is acceptable. But the best is good. The parrot flies to the most sensitive spot. Raw nerve lands there. Good for you.

Ted wakes me up outside. He's singing, "Drop yr cocks & grab yr socks." If it's Monday this must be Korea and I'm an orderly shaving to his blaps. Fielding Dawson was the last one to sweep up around here. The whole bed's aroma of Ben Gay in deference to the lower back, sweet watery themes. I make a perfect U-turn in front of the post office and Don's Liquors and straighten out aligned with Seashore Realty. I once published my objection to a fence. Fern Road dozes in its kitty litter, a helmet with a faceguard under pampas grass, vacuum arrangements for coffee and tennis balls. Petty irritables take umbrage at greywater. Two more than one I turn into you. It's no hardship but what in dumb fuck's name am I doing with here what am factor of absolute importance to this scheme? Last day, no gold watch? Name brake, blame's sake at the battered gate p'diddle companion of sleeps. Phone rings Mose runs "I'll get it, I know it's for me!"

9

It's just you, only me. Fuck Mexico. Coastal fog burns off. Kent Island gleams like Rameses ramified. Ebb tide's a marvel of slick dispatch. "I'm going to get my action figures." Shasta daisy pokes out of the berry vines white as a Tuffy, a sheer porcelain tremolo. Every so often she turns over, belly to ecru sheet, and reads another paragraph of *Lady Chatterley's Lover*. "No credit. Can you imagine! No credit?" When a clear solution of need discolors the eye of another, you cry. How you cry. How I wish.

Dan Rather, I hear, gets all the girls. Ashes, sand, clouds, incense, fog, haze, bubbles, froth, spittle, surf, spume, phizz, dust, lint, cobwebs,

fuzz, gnurr, lava, calcium deposits, stalagmites and stalactites, steam, stains, sweat, mucous, urine, shit, boogers, earwax, dandruff, psoriasis, pus. Smoke, semen, and catarrh. Phlegm. Blood. Stitches. Ovaries. Brushes, bedsprings, old tires, sheetrock, compatibility, mice.

Mr. Spock says, "Every time you humans encounter a structure you don't understand you call it a *thing*."

Here's the format:
Life won't come fix the car. Grey day, mind a-many, a mule train and overexposed. I circle myself into the 40–65 age slot on County Library fact sheet, quite a jolt. Pale ink effects gambol over textural densities. In Celeste Ville, a thing a day. Dagwood's suburb doesn't have a name. Peritonitis is not a disease of the gums. I don't want to be left alone to live in peace. Flowers can't want to read.

"At least it's clean"
"If my thoughts were that gentle"
"I hope you hated me"
"Oh, only briefly"

Happiness, half-cocked moon, gentle innovator, can you write poems?
Yes, much good it does me. These rocks have no madonna.

At the bookstore the
point is we must stock more 19th-century novels. We can return last year's Dostoyevsky and get Balzac. It's hard to remember if there has been any profitable turnover in the area of, so to speak, Dickens. Bukowski isn't moving. Used Melville sells pretty well. Nobody seems to be able to predict what people will read but it's plain to see what some of them are reading. Things by women get read a lot. Guides to Mexico and Yucatán are popular. Local authors are sentimental favorites. *Shibumi* is hot. Last year around Christmas we had a lot of dance books but only the ones with mostly pictures sold out. The big sellers in fact have been greeting cards, health-fad books and cucumber soap.

The gravel
has held. We're crazed infidels on the verge of mixed emotions. There is a strong possibility of drought. Lumps nodded like cat to slats under the Motorland sun. The meeting "and now we have this kind of set-up." It looks like we're on dry

land here. A mirror undertowed in concomitant purée is unacceptable. The people must vote. The *National Enquirer* tells lies. We have had it up to here with broken promises. Tom likes Jim. He can see what he knows. Go to Gary, go to Gary, go to Gary, do. "If that phone rings again I'll kill it!" Music on the radio no one ever plays at home.

July has parted with its knee-scrape scabs. And outside everywhere the moon. I can't get off her. (How come I can't hear her who am her voice?) Dream I'm telling Arthur and Suzanna how it feels to be 77 years old. "No difference really, but look at this shirt!" A white heavy muslin, one hole in the breast pocket flap over my heart. While in the awake-state, I'm taking on the kitchen: Wide sight of whole cloth, chrome, tile, wood, stainless entireties, glassware, ceramic, plastic knobs, all that centrifugal architecture of a stove. Vegetable matter. No wonder painters go nuts. The way eye-tossed brain snaps to detail every time and the scene, all manner of message honking, not like a syntactical Dutch kitchen, yields no singularity long enough to say "There." "Stop putting smoke in my face!" "Wow. Did she hurt herself? What did she hurt?" I'm such a '40s/'50s person really, I always call it an icebox.

The cat's eating Obi Wan and Babar's futzing with a padlock. The world, after all, needs a place to work. Did Dante misremember? Seeing the sky, demanding hills. Can this be America's lesson in love? "Be prosperous and nullify." Albeit minor intentions are seldom lost. *(Letter to Maria Gisborne.)* When from the Wish Star the Blue Fairy enters domestic space, the room goes blue, the star comes out on the end of her wand, the air sparkles. It's a small desert. You see a faint figure on the horizon—vaguely disheveled, bottle in mouth, waving a shirt—probably your friend.

That part of the room love's in looks good from here. A welcome tree at the yield sign, that's vital.

A Copy of
the Catalogue

1984–2000

FROM WHENCE IT CAME

In a red chair with a toothpick
A space heater agitating
Between categories, scarcely heeded

Destiny slipping away

But you caught the culprit
Bidding him drink of the inland sparkling sea
All dressed up, real pretty

FIRST TURNS

In present comfort, a tethered box
how far and astigmatic seems the plea
beyond peculiars and asides
and quilted veneer wilts
staring into penny-loafer shade.

A titanic upset only chaos has delayed,
magnifying real cottage brands of stasis
moored in the vertiginous some floors up.

Familiar schmeer, by the lessons of which
an America dragging its heels foists helpless
love of circumstance as the match approaches
direct to "bat"—aroused utility blurring angle choirs
in sopping wet rain, prescient of how
to monumentalize the crypt.

Mad boy heart's face froze insouciant
wading in long salt under the gun.

INSTINCT

A mildly hostile point
breaks across the table
and is an organ of breathing
much as Hector and/or Ajax enthusing
over *The Oxford Origins of Cures*.

She always gets the dish the others can just about stand.
Then I'm sick to my stomach, writing off morsels the oven's already
turned down. Ever a tale of brooding capillaries
exposing a genre of matched sets: isocolor sweatshirt and grandma's
earrings, a fuzzy muffler and muff.

The table gets rounder than was guessed.
Its imagery's dowels are trained to bid us
become the masters of our age, not to act it.
No suspicious empathy, ambassadorial
to make solvable the hornet's trick of dream
as childhood's taller girls' in closets meant.
And if a tree falls to the ground
the earth will close and crown it.

STOPPING IS NOTHING

Talk back to dreams even inside them
Spotlit rage tells charm's belief
Passion as a lattice levels air
What sun obtaining will enter your sheets
Burning like all get-out

The steady patter like an absence of remark
Matters much as the motive
For bad feelings in deep sleep
Or fiendish forgetting withal of it, them
Windfall of chancy flutter and flit
Whether or not the deep-trouble kind

END-OF-CENTURY THRUSH

pins softeners
striation more pick-and-choose
face centrifuge outside rafters pillage
under dark to drink into my wall

old-wine allegiance
animals are balloon borders
refuse of cream rinse
the canvas further a canal did Braque

which but candle devil canard
his little light to sail outright
lugging peak of pale napes
"Get two!" nailed to a Yale thatch

Gurlie repairs the lull in soaps
"poor art for poor saps"
swish salute to particulars at sun flats
matted melted melded reeked beheld

early ignorance
chicken Kiev
"The truth for a day sat on his face"
mouth of June

up, drive
down, clear the navel
predigital in the bud
noyadea borscht-out!

Miami of Ohio-crowded curs
flinging sheiks along the Seaboard Line

extricable second rivers
erect success

fast first future for none
only to seem what becomes one
thwart bald spine
soothing the slab quarters

realism's liaison
disfigures the zones
snafu seventh-day trance
trench recedes receipts

"THE HOOLE BOOK"

Day after Labor Day first day of school
Balin slew his brother Balan
I because you

What is it about what we do
Militant music makes a muddy ghetto of ears

I'm crying all the time now
And faking every little thing

I say it a few times like this:
"I don't feel like going by myself to the bar"

Many roads do not lead to art
This gun is soap
To make yourself a rose, crush the package

You wish to cohere, so come here!

Sleep which defends no property
Oversimplifies the fabled
Unpeelable pit

I saw him lapping up dishwater from the sink
Now there's cat shit on my shoe and no floor

You seem to have laid claim to this puzzle
The ones with just words are plain bullshit
I walk in beauty for my sins

Being looked to being looked at being looked
Into looking away

Yet most of the ones I loved were there
Dismay sloshing the sides of the glass coach

Which were no worship but shame

Quel mess
I mess
One must
I keep the grammar in blood

A favorite plant has reproduced itself

UNDER A CLOUD AND AFTER THE WAVES

after Lyn Hejinian

real winter flips
lugging the year bed

reverses no mean can evade
Dagwood corrugates

he stood raving from the dance
solution primed under no bottle

went for the shoe
it was barely awake

latched onto a big fast bus
his flailing tongues to ride the lunar

each far-flung crate before you useless
but that furrowed head

pounces drawn
and as betoned

CHASING THE SLIP

What choice have I to lift as mallet to my stake?
There's a hair in your pine, muddle,
Impeding the switches of I never do decide.
Nuts to this bulge of condition then, that doubt word,
With stiller things backlit against its peaks.

When a woman looks at a plant I walk behind
In boldface, noodling every twig that leans,
The wear and tear and slash and burn
Her fabric audits; and when a name escapes,
Animate in fog, I dub it.

NO CLAIM TO THE PUZZLE

Fragile as the glitter on Dame Felicity's eyelid spans
The visionary view. The day burns all costume and
Valence, face of the richly bearded sod.
Teeth showing and the eyes exact in it.
Great sky, greater pressure—
O perseverance the fuel and patience the fart
And pride the stripéd honeybee!
The farmer takes the hunter's wife;
Thus has prehistory entered your life.
You start anywhere. It goes a long way back.
Another heave at the Worry Wall,
Stucco postures on the heavenly bandstand
Where only tubas play.

MANDATE: ARCHIE TO JUGHEAD

I won't make another empty inventory
copied a hundred times across the board,
arsenal of declensions that never break the mold
with good reason inveigling
impulse to poem with no sad words.

A sonnet's about the size of human talk
slyly founded, with mirrored character in mind,
crotchety, melancholy, blue—
the landscape taken from a landscape we knew
taken for words, bearing their own stamped trees.

Then if I steer clear, combinations of earth
must bubble away, and in the death of the bandstand
you are bequeathed, catering a taste test
with white gloves in the sempiternal field house
gathered like hair down the back of a shirt.

Let them stick or be flushed.
Although the weather suffers generally without people,
the pale loiterer can still be found
in thinly managed time
plotted by the transverse—

a successful inoculation
at the gnome's wrought door,
having bypassed absorption and succinct betrayal,
that possessive rule we keep to a brain
as in: I stole your letter sweater.

A HEAD AT THE COVERS

I removed the rains and motored
and flipped through the covers of a board
a card with shavings labeled to a lace cross
in the mirror-narrow confines of an
eyesore fog you can fly
over still and put
your finger on a dune

as if pins were
to be pushed dimly
inches downward from
a manila star

What if the panic is on
and this parrot weather
has crow's feet
which aren't a regular part of the job
but the deep end of a lot of things
that leak their loads like twigs to the vortex
an uphill travail

Unlivable sounds stem from the woodworks
traipse on the back of an igneous broom
that busses bees to certain rarity

but I'm with
the sun bolting
all the ledges
my odd blue dots anchored
I barely think to what
since what has gone and merged

The whole inch piles on gathered corks
the strips in place are a snore of blue
a while so lifted you watch it shatter care,
lacking evidence, with personnel to spare
I left a face spinning on the stair

MELTING MILK

Do things then happen
despite our knowing
and is each misnomer

but a dream? Natural hiked-up
detail consciously
during years of anxious

foreshortening, now distanced
by tinsel, cup, ring, ball,
heart, horseshoe, snail,

acts like visibility
of tempos irreducible
to a fractious stance.

So find any plausible footing
and grab: Do we get to stay over?
"Sorry," says Recorded Time,

"didn't get it, lost
my concentration." First error:
the profile seen double

smoothes it out
and forklifts ballast. Verso,
enter nameless emptiness,

heavy on comparison, contingency,
conceit. How's it getting dark
because things line up in a

massive buddy system, a grab
bag of rimless data,
milking lights, red ball to green spool,

as we think.
Ash is crystal.
Ecstasy is near.

SHELTER

to Jim Brodey

Do you recall the words to fog
or flotsam slipping legs into the laundry bag?

So many have left the human party
'twixt meats and jellies
that now seem pitched from chill couch ease.

Their message units stroll anelastic yet duly personable.

A jocular finality holds sway
at face value, like a multinational elation cell

sounding the twisty miles in tow,
some original mass remanded.

IN A HAND NOT MY OWN

A blank wall is singing
to be separate from the rest.
It is too mild for the casually attired
to be living among their glittery glassine poses.
Or else my superstitions are wrong,
built sideways from a limb, or anyhow panting.

But why fuss? If personality were legal tender,
ours would pass for coin of the realm. As
it is, not one will stir for
the detached, the slow dickering of affect
and demise leading to the dustbin at heart.

I speak volumes across the rim of a quail.
I glisten in footage to smother all currency
and as I crumble I succeed,
empire-elect of a most honorable science,
knowing the babble that toil concludes, condones.

THE OBVIOUS TRADITION

I haven't remembered anything, only the names
and that their dates have been replaced by fees
toted up out of mischief:
a whopping yellow sun, finesse swallowed hard,
a scrapbook in pantyhose dawdling beside some Shreveport-like expanse.

But now you see it, she's supposed to call.
Surely neither will converse, they merely tell,
succumbing to a disorderly shelf life like Tampax in June.
Salute the budding terminus where the East Side was.
Can there be a way to redefine the tense behind its jaunts,
the pubescent imagery a hand calls forth
as, rippling, it is thrust into the brine?

 The phantom tugboat slips along
in depths past Garbo's awnings and the united glaze
which wilts, harnessing dim signatories in the windows' sarong.
Do things go further in need as I could? Or are they immune?
How else have I been taught to guess
and then been told to know, because matter equals good?
A silken light masks the entrance to the market proofs of time.

WAY HOW

Markets hit return
the egregious debauch
and in the garden

ever remotely broken car:
Contempt City at the bypass,
creasing good-natured binges.

The layouts of minus
squat on the rooftops
of princely Eden.

Wet jewels waxing into struts,
waltzes, thankful factory scraps,
hot potions brought in on trays—

the way it sounds at this end.

AT THE SKIN

for Francesco Clemente

 This living underfoot
pale woven weaponry
 to each its
 planetary influences
 ever on the mark
 exceptionalizing
capable, probably culpable
 I am turning 50, a worker ant
getting a grip on
 the spirit graph of Florida, Maine,
 Queenie the dachshund
 and the several areas to the left of
 sketchily Urdu
 the reasonable pretense.

The tattered movie screen has taught us to question our betters
the truth of it is it isn't butter
and you can't get a grave on a bun

but the pinwheel releases a lot of costly packaging
 that helps the light
 in elegiac lengths
 become extrinsic
 like pure.

ROY ELDRIDGE, LITTLE JAZZ

A hard look and fake I.D. won't get you
into the Metropole, but at 15 you can stand under
the marquee's heat lamps outside to listen.

That epithetical "little" must've
implied something synecdochal
together with a downright

brevity. Eldridge was his own quintessence:
as Billy Tenant expressed it, "the guy who
could squeeze anything out of a trumpet."

His playing contains no stunts or slurs.
Each bitten phrase meted out with compact dignity.
Where the trumpet blares, its pointed elevation—

zigguratic high notes, chomps
goading (in Kenny Clarke, for one) a concomitant
reach in rhythm (the ride cymbal rose

in prominence)—
with an aspiration like the Chrysler Building
clinches the night air.

GRAPHICS

Epodes of bat in city streets
Sucrose end-alls spraying rural yards
Oil poured on the curious ear
Pressed against antibiotic, zero breast

Green gum and a dribble
Occlude in revision of clean pines
Overdone as expensive
Modulation and nubile fender drifts

Little light skims from the top
But there lies the clever ground
Usurped by the rightful observer
Restoring to us our vanity, his carte blanche.

FUGUE STATE

Worth mentioning?
The horizon, such as is, splits mind across the middle.
To turn in this world first: mirage
of motel swale, votary albumens checked in coils, an ionosphere of certain age.
The check is in the mail. When this arrives, millions cash in.
Gone with its physics, the downy mist from motor inn planks.
("Once I chased that same white vapor down a soft shoulder near the Music Tent.
It must have been a singular joy to spy at dawn beyond to stand deep still and feed
 the stains. Signed, Do Tell.")
It so happens, what chemically will invoice time to a rug shack.
Gone tree, the alder now a gilded stump. The gridlock rose has mattered more to some
with less and less to tune, please notice the smallness pending there.
That species worth mentioning?
It will all return to fugue.

Say to yourself I used to.
Let me count the ways to say I don't.
Sexual union once was a paradigm.
The '80s, though, afforded little random socializing.
To operate both as a family and work at home, how many phones do you require?
As in a fatalistic French movie circa 1957–1962, the plot element creasing a white
 linen suit,
who taught you to smoke and drink and carry on like that?

Amateur self always swapping cartoon bodies—
not to mention the abstract wisps spilt in recollection's meadows,
house guesses plaited with resumable, squat truths—
haven't you felt Mighty Mouse's female counterpart (can't think of her name) lean
 on you
with lips of high-gloss ginkgo dew?
A seed bag of gravels for her furs!
You take up a quill and inscribe the day's prophecies in nomenclature without apex.

Beneath fumes, the project turns to swatting the states upon the hump.
This visibility is notably perfect.
I apportion whomever crosses under the lintel, but ever it falls to me.
Gone are the states.

"Arise, Sir Knight."

Whom do you most admire?
What is your least favorite egg concoction?
Which preposition best exemplifies a grassy ridge the likes of which you see
tantamount to yellow, desirous, resinous, albeit past all mention?
Can you actually write in the dark by hand?
Commit each folly? Tear down advance notice?
The plums fall, nicked by stingers.
A feather squeaks in the leaves.
Tuna leap from the ocean at 360 degrees.
The more alert among us sit up and take notice.
Echoes in the machine part company.
One by one, the prawns mounted the barfly's plate.

The past is a blur.
Perhaps its task requires some special knowledge, feeding afresh on what is
already given, a history of unintentional deletion embedded in its own
 epoch-making pause.
Oh yeah? But, hush:
the letters wait on each vocable in the halls of permanent digress.
They jangle, frowsed in mint, whole mounds of ends.
Letter of detriment the silhouette won't resist.
Stupid language.
The car is ready, I rise, scaling Everest.

A stone leaf.
As monetary as teeth.
The box pictures the box.

There is just the mold (or mould?) of appearance proffered by a jelly jar.
There are administrations more average in a cup.
Bring on the menace, lest we euphemize the while . . .
The air smacks, understanding little and bilious.
It should learn to read.
But there is too much meaning to leave us from meaning more.
(I finally heard and closed the book for fear.)
Something characteristically physical lifts its hind foot.
How many deletions are still to be made?
All that seems is substituted for on the inside out.
And how will I know such shifted givens, O custodians far from home?
When you leave the building, things suspend from here.

DEAR CONSUMER, THE ESTIMATE IS HIGH

The accountable imprints of the Grim Reaper
will have to be sponged off as click-click
the color wheel spins, scratching an itch to
the left of my shoe and staying an instant the
untoward of loss. An importunate diary
has had it thus, whose neighbors
imbibe the shanks of emotional tact
in which conviviality is depicted in ten
directions at once, and it just goes to show

the itch disappears with a toothpaste grin
that just goes to show you expressed some
consternation as to its ancient character's
surface tension in a cup rattled by traffic as you
write the check in folly at the perimeter
of this needless star

ENOUGH ALREADY

Time I do and if I don't
That particular wall seems tireless
Start a verb through the motions
The motions all ring true

What I didn't see or do it says double
In the proffered ranks of brim and arc
Ever verging on a world at bay
Tended-to as take-home pay

CLERICAL WORKERS

We have costs below our limitations
and worries meted out for those who demur
to pull their weight. The market is fixed.
And hell is versed in stains
and bifurcation spells an edge
flat-footed in the afternoon movie.
In this case, the lady's dress
feels serviceable and sticky as a Peter Paul's Mounds.

Another pretty face fakes out the scenery,
candlelit:
Mother knows you're nice but not how much you lie.

There is no percentage that comes from being set in Utopian ways.
All our assistants have passed through accredited points
where the assailants yearn,
gone slack.

Please, we will bring command to your private rooms.
Candies by the switchboard tell of management misfires
communicable by union, cubicle, slap, or chill.

BINDING GRIEVANCE

Relief filled with donors
appetition skips a day, an hour.
Impressive muscles grow among
the hilly routes between.

This is your interim contract.

In the undertow, as Winslow
Homer saw it, Miss
Liberty negotiates her wits,
a core problem that functions
primly. The diverse throng suited up.

Everyone is a kind of Miss Liberty as far as
the powers that can be seen.

Line at denuded salad bar
slows: key under mat;
oxygen beds; summer,
pianissimo woman.

After the dust had settled
between speeches,
classes will resume.

Call us back with your name,
or could you do without?

A FINIAL

I can see where the sky takes a bend that the fogbank
hasn't blunted. I see the drawers pulled out
for access to same. If you are so inclined, matter can
be sensitive to the need for a shove.
I feel the finesse of particles at hand.
The origins of shape stare out from indelicate depths
where subjectivity can't follow, spilling itself.
Evidently, perhaps.

IN GRAY SWEATS

1

A hidden logic exemplifies
stasis turnabout approximate to mildewed VCR
concentrated scenery pours
(Samson in the guise of Joe Camel grasps the lion on Trump's pediment)
where equity recedes
and her mandorla deepens
taking directions in terms of efficient daylight
vacuum motor fulminating
hair caught on a bus thrown back
theory each millennium propounds
in loops that recur
that an O-ring may need inserting at the Fed

2

Artemisia Gentileschi supersedes Joe Blow
painters are the first to go
they put up the details roadside,
the likes of which a squashed pink balloon with a bright girl inside it, a whiffle
 ball, rarified vehicles and gates, yellow hydrant, my camp moccasins fouled
all things pigmented, bookish and nerdy
practicalities under flannel skies
sensation argues a metalanguage
predictable glass charge, serve with sediment, mentia
in whose poems we carouse, *por favor*, swimmingly

3

Facets of rank, appetition, attitude
dreams of status spearhead ebullience loss
our communal check deposited in advance of payment
the plans arisen like nothing we've ever seen, dark star
and I am glad to know of them

thriving in this sizzled atmosphere
where thought exchanged persons
for the long haul

Cover me

a rouged-over tetrahedron bestride the poop deck
ten little *indios*, whomp! a dark picture of a waterfall
enquiry into the origins of our ideas concerning the sublime, the beautiful,
 the mind/body split
a nonsense split
since this is the sum, the share-the-never ennui lapse.

FOR JIM GUSTAFSON

Last Words

"That's the way it goes."
"More light, please."
"Whose side are you on anyway?"
"Goodnight, sweet Prince."
"Shut the door on your way out."
"You want I should call you a cab?"

Gimme a Swig

There must have been a saturation of enchantment
at some point before the crafty badgers dismantled
their catch, the Actual, for meathead determinism, pestilence
futures, subdular glitches, *et alia*. You had plenty to read,
a river slipping, sliding gently through it
every day, the first pineapple.

VOLITION

He follows words and puts his thing to them.
He chews the landscape to process.
He is strict and bound to stand.
He smacks of fill and compelling evidence.

The field guide says there's
 a pond up
 the fire road in
 the birches.

He is known for judging the lights before they are put out.
On the ulterior of a live tree, a double door to you.
He wants to know what still hasn't happened.

TARPS

Modern sculpture, the wreck, embraces
inebriations of Khan.

Gosh, look, Walt, they are laying
track on Market for the Muni

in this town of white and pastel girls.

Sandwich yourselves, for appointments suck. My clothes
un- or over-encumbered in drawers must strike the set.

Surreptitious self is it.
We don't want "It."

Between door and post obtains
an arithmetic.

THE READER'S LOVER

Cannibals
A Marxist is cannibals.

The Former Ambassador
If we could talk on the 'phone one day, all of this could be unraveled.

Ten-Dollar Words
I am a product of my time.
Sociopolitical grief is the name
in anybody's book.

The Forest Folk
Patrimony sings!
Opera! Infinitude!

Half Man, Half Beast
One man, one beast.

AN EXAMPLE, WORTHWHILE

Single-point perspective got fudged.

The bird in the house flies in the eye of the god

Lounging at length across the field, a simple song.

One has to envision language or it's no help.

Know history backwards.

Lay into life.

SIGNATURE SONG

Bunny Berigan first recorded "I Can't Get Started"
with a small group that included Joe Bushkin, Cozy Cole
and Artie Shaw in 1936.
Earlier that same year, the song,
written by Ira Gershwin and Vernon Duke,
and rendered as a duet patter number by Bob Hope and Eve
Arden, made its debut on Broadway in *The Ziegfeld Follies*.
By 1937, when Berigan re-recorded it in a big-band setting,
"I Can't" had become his signature song,
even though, within a few months, Billie Holiday would record
her astonishing version backed
by Lester Young and the rest of the Basie Orchestra.

Lovers for a time, Lee Wiley and Berigan began appearing
together on Wiley's fifteen-minute CBS radio spot,
Saturday Night Swing Club, in 1936.
Berigan died from alcoholism-related causes on June 2, 1942.
Although "I Can't Get Started" is perfectly suited to Wiley's
deep phrasing and succinct vibrato, she recorded the ballad only
once, informally, in 1945, during a Town Hall performance date.
The Spanish Civil War started in 1936 and ended in 1939
with Generalissimo Francisco Franco's forces entering Madrid.
"I've settled revolutions in Spain" goes Gershwin's lyric, just as odd.

A COPY OF THE CATALOGUE

Red Harvest: a property filmed by RKO circa 1933 as a musical comedy with a gangster subplot.

Red Harvest, starring Marlon Brando as the Continental Op, directed by Bernardo Bertolucci, shelved.

Red Harvest: Marlon Brando *is* the Continental Op in this film version of Dashiell Hammett's novel, directed by James Bridges, who died before filming could begin.

Dashiell Hammett's *Red Harvest,* most excellent film-to-be.

I will end with a lapse.

For an untitled chair, culture, culottes, Charlotte Corday, Robert Cordier & Eileen Corder, rec' room, Charlotte Rampling, Sock & Buskin, "Buckle down, Winsocki!"—"Plato or comic books, I'm versatile," brewing coffee through a windsock, Paris-Orly, 1964

Paint settles on the support
arguing the art of *pittura*
into the ground, where it surfaces—
part color, all manner of light—along the edge
 given a proper viewing distance
—to converse in color: "the perfect figure of measurement in space
 and of restarting in time." Now there's a thought. The periwinkle

garnished, the sperm bank. One befouled character recites imperialist
atrocities while another regrets the impeccably tailored English
suits his mater gave away to do-gooders during his stoned-out,
hippy-dippy, bell-bottoms phase. Who didn't do what to whom?
"I spit on you, Yankee dork!" Yet doubleness dogs our days only
once the admissions committee attends the proconsul's clip under
the clock at the Biltmore—oh, please. Protracted swoons.
One of me's head decorates an insurgent's dull green pike, or its
twin, as the young and restless storm the comfort zone, valiantly
punching holes in my alpaca-lined, velvet pup tent.

PURGATORY

You know how
when two red lights

flash in the rearview mirror
and it could be a cop or only another

motorist braking
in the opposite lane?

That's just the way it's been
with me, somewhat.

A HYRAX ON HER SHOULDER

Degustibus does as Porky knows
Blue Terpsichore, a laugh riot:
Fated radiance, a soundtrack pending, holds
What takes one away to logic from your arms
In foregonest night
Neither thimble of death nor congealing old-age creeps.

STAINS OF STALIN

She knew him somewhere between five p.m. and the next day.
His gaucheries were dire and nimble as iron socks.
And they rang, likewise, suppurating as
A glow along the Silk Road, as she
Healed her brow in the hospitals of a book. A stiff life
Intervening in the parlors. And then the crunch. Luncheon is served
On the patio, I kiss your hand, Madame—the epoch echoed
Such aggravation!—inside the thatch, the tablecloth,
Implying steely-eyed ambiguities never completely foolish enough but
Subject to derisory forced laughter brought harshly to bear
On every mother's child, as well you and I both know,
As well as the heartless, neutral, vine-colored
Slabs we put them under—
Only, angry birds that we are, I forget just which.

THE RECITAL

for Eric Fonteneau

It is said that, late in life, Denis Diderot force-fed his wife Nanette a diet of R-rated poetry and fiction, including his own *Jacques the Fatalist,* as a cure for her feelings of moral superiority. Diderot read to Nanette morning, noon and night, and whenever the Diderots had company, Mrs. D. would recite to her visitors whatever she had just absorbed. Slowly but surely, the cure took. "Conversation doubles the effect of the dosage," in a letter to their daughter wrote Diderot.

LA POÉSIE BLANCHE

I'd been over this once before.
I came out here
and went again
later, to see what if
anything that had been was left.

Yes, it was, and all of a piece,
yet not much else, or less in point of fact
than then.
 I wouldn't want to have to
turn around and find myself passing what
might have remained there fully, no matter why, in the bargain.

MEMOIR BAY

Succumbed to the art houses' clunk, my Mae, my Max?
Pry open now the lowly owl pellet so as to peruse

Lap, the car talk, the Boston rat catcher, vigilance
Bones eclectic in the manor, blinkered in some slipper's cap,

A mole slide's third's tainted fab blue hoot avail,
Taint, tawny micros stippling about a ditch,

On the brain gold feed plaques
Blend, the unissued stamp.

Great British tendencies parade to scumble
For their prehensile bearing inside Arcady body's blowfish

Disallowed toe quirk inclusiveness to Vendôme sashay
Brag an indifference at heat junction attaché, "no dice."

Plug archaic sense as surefire grid or folkway guide?
Film flak for comportment over desuetude event flop?

Like Benito Mussolini astride his trike,
Cupid and Psyche like each other.

Here where longueurs make or break the rules,
Losing is precious, heartbreak cool.

Maybe what you had all along was a cold.
(Search this site for lip.)

The thing you are swallows greater the stirred-up vendor base.
The jungle wet with index flings back an outer-limit margin deal that stews
 process through its sieve.

The mar is hardly fatal so lets us sniff it at about street
Level. Blithely pressured, the stupendously straight barebacked waitress at the
 Right Bank Cafe, Elizabeth Ashley, said okay, you got it, seated.

BY HALVES

do limits build
both sweet and cruel
or over to you off at
your compass studies,
visor to odd angles perforated,
plumb to sky
to service mouthful signage in pearly
cantina load where squawks from a ceiling,
headed down the demon slopes
for work place, total their sheer
carbon feed on an average night
that at any guardrail slick nails the morphological in bins?
Thus backup wealth lifts an ancient spume, glowering with grammar
whose joined bronze gives pause,
erect lapse paging glory, when wing is rag

After the Medusa

2001–2008

SALAD SPINNER

after Francis Picabia

You must grab time by the hair,
couple subconscious helixes
in the space of a secret.

You must tickle the improbable
and believe in the impossibility
of crossroads.

You must learn to suspend
ten grams of white, five grams of black
in hopes of true scarlet.

You must know how to fall from below
to favor the zenith
of mornings to the manner born.

You must love the four mouths
floating around the silky doubt
of dead assumptions.

EXTREME PATIENCE

Of those who, believing the world would end that day, assembled on one member's front porch and sat, waiting in the event that this should occur—it hasn't, and at sunset they get back up and disperse to separate houses until called when next to witness such desirable oblivion.

THURINGIAN EQUALS

Crossed fingers gird the planet, though small optimism obtains.

Will I read *The Serious Doll* in wraps, with its roller slur?

A book where everybody, reader and writer included, dies.

The kind of thing people said in the 1970s: "Hello, I'm back being me again."

My first and last names and the first and last names of both my parents have the same number of letters.

The wasp waist, the tennis dress, the shirtwaist, the dirndl (Mainbocher).

A distant yet achingly distinct whinny: *et voila!* the walking buckboard.

Dustin Hoffman's bookcase hanging by one hinge in air of Eleventh Street, dawn 1969.

Telephone solicitation for a ballet school in need of "serious floors."

The thought of someone flat on his back on the carpet, tossing and giggling.

If it hurts don't do it. (There are several *unless*es to this caution.)

For the second time in two millennia slept through the meteor shower, results of last night's talk.

TEN THINGS ON THE WAY TO SCHOOL TODAY

for Michael Krouse

The leaves on the tiles inside the front gate. (Windy night.)

An extraordinary, slender, intense woman alighting from her car on Franklin near Oak; when I looked again I saw she had gone to a pay phone on the street.

The pseudo-Gothic church on Franklin and California—it always rings up "beautiful" and "Italy" for me.

Through a window I notice a woman in a black bra working on a computer, her face glowing from the light of the monitor.

The hefty motorcycle cop who sped through the orange roadwork cones at Union Street. What if I had taken the turn around those cones—and the earthmoving machine that blocked my view of him—as quickly as I almost did?

The Chevron station at Union and Van Ness and the two Asian guys who work there goofing in front of the garage lift, and the preponderance of suvs at the other pumps around me.

A very long white cloud shaped like a hammer.

Signs for "Air Circus" coming up (I forget which day) at Crissy Field.

The confusion of two lanes on the west side of Union at Van Ness, all cars aware that the far side is one lane and that not all cars on the left will signal if turning left.

A woman who looked amazingly like 20-something, blond Riain, but who, when I looked harder, was about 60 years old, waiting for a bus.

NO DANGER OF THAT

Pages from Earth,
glades, furrows, cemetery plots,
a painted band, like a mongoose circling a snake
every half hour

angels of indeterminate
no idea too ingrained
simple glass flash

more violins ahead
far down the enfilade

skyway miracle
issue of durable power
cause for celebration
in time for the next

CHEAP SEATS

On the telephone answering machine, a sly recorder rendition of "Be it ever so humble there's no place like home."

Similarly, heard at the gym, a country-western singer describing the girl of his dreams as "Picasso-esque."

Once light bounced on the nearby wave. Now it is riddled with troughs. Nope, you are none the wiser, even though the crime is solved, the brat smirks.

NEVER HAPPENED

Fatal business, near-poems, virtual fatalities
no gloom intended, but see and say
"Morning clouds burning off before noon."

Birds fly in a family of bird life
listed along the chart of the sky.
Where else would sky be

but all around each
peculiar bird, all
optimizing ways of being themselves,

the rest of us inhabiting our typical morass together,
trading sores, consciousnesses, death underwater
(18 men in a Russian tub)

ENGLISH SUITE

"I refuse to take Glenn Gould seriously," she said. But I corrected her: "Not only is Glenn Gould serious, but he is seriously funny." The stony silence that followed saddened me deeply. "I'm sorry it turned out this way," our hostess said, as we went upstairs.

AFFAIR

On the ocean liner deck in *An Affair to Remember*, Deborah Kerr produces the cablegram from her fiancé but the wind grabs it out of her hand. "And *she*, will she be there?" demands Deborah. Cary Grant pats down his tux. No cable, but "Yes," he frowns. Deborah stares into a wave: "We missed our Spring."

ASSIGNED AT WILL

She said it's like learning to tell time in
a foreign country—you got a
problem with that?

A calcium deposit in deep recesses
puts its chilly finger on the issue.
You neither move nor glow.

She's fumbling with the zipper. No zipper.
The platform proffers a Tuscan sunset
together with petty theft. The time sky does a light feint.

REGENCY

The Louvre has the best collection.
He died at the Louvre.
Still lifes and genre scenes
In a steamer trunk bound for Boca Raton.

Meanwhile, at the École Pratique des Hautes Études
I have to write something understated about how ideas
about art or what life does or won't do clear or not
tend to be lifelike, absurd or preposterous.

Of days among the living these were the most
Teeming with aura of air and purpose.
Between prophecies, we should prefer a glass-bottom boat.

DAMAGES

Number 53, dejected,
mitt in hand
pressed tight against hipbone—

how I gave you away
to those two I no more
care for than

the ball
in zippily fashioned grass
deep right center

MERIT

Sorry for the suffering, world,
reaper of sutures, in point of other surface
 beneath the silly sheets

What conditions lack is truth
in the absence of conditions
 same blank din, soon to be released

Oh boy, oh boy,
the color of your knowing this,
 when you do

Tromping through the snow
to see the pictures, cleanly made
 by this year's nut

GOODS AND SERVICES

Are you a 15th-century Italian monk of present-day ill repute?
No, I am not Savonarola.

Whenever anyone steals something it is Prometheus
But theft is ascribed to Hermes.

Word went out that the missing husband had been found
Behind the house, washing his pants.

So Lady Light lets drop another of her interminable fireballs
And you are no longer suspicious, only all the more turned around.

My class notes are illegible.
False Spring casts its ballot of blue. Code name: "Clemency."

IN COSTUME

The endangered energy guys are coming on a Monday
And the steamed-up picture window (time being what it is, its prolonged
Disconnect elaborately personified) wavers blue-ishly spotlit,
Affecting a slight concussion to face the styptic deer.

In the parlance of permanence many bulbs need replacing.
I heard the woods speaking but they went about it the wrong way around,
Panting like mutts in the leafy strata.
Unlikely lunch: Dark toast soaked in soup du jour.

Agnes Moorehead, Goddess of Nimbly Erected Spite, tell us,
What is it that will make life palatable when so it is?
And lunch absorbs from light executive privilege
At the high end of the cerebral cortex afloat on my fiery palatial plank.

She flies! The saucer can't *not* act.
The clock is whole, its animations invariably tingling,
Recruited to receive pronouncement of the final
Anagram hastily received dark nights long before graduation.

SIX EPIGRAMS

"The Anointed Hour"

The Graces came to my door, too—
green bronze next to yellow enamel, mounted
over rows of well-weathered cedar shingles.
I've got to go out for a while, I told them,
make yourselves at home.

Among the Crinolines

A champagne bubble from the 1950s
 in the air still

 What that champagne felt
experienced never forgot deemed
significant when you cried
 its other bubbles burst

Friends

My friends are ascending,
 inadvertently occupying
positions of importance in the
 contemporary pantheon.
Destiny does things like that.
The rose shimmies with enjoyment over itself.

Reimagined Episode

Snack wrappers crinkling down the aisles.
 Cabin pressure dropping
 in the lap of the gods,
 Flushing Meadows.

A Lady at Her Writing Table

I chose love and friendship over
 work, then
 work and friendship over
 suspended disbelief
 —won't love conquer all?
 I'll never work again.
 Don't call me.

Plot

There's always a pretty girl in the plot,
but nowadays she calls me "Sir."

HEINE SONG

The rose, the lily, the dove, the sun,
I loved them all in love's mad swoon.
I love them no more, I love only one,
Little one, lithe one, pure and true;
Selfsame source of all love's flows—
Lily, dove, sun and rose.

AFTER THE MEDUSA

I have to spring lightly to make or thwart a meaning
bare thump at the Safeway's automated door
birds in their vanishing act above or near the U.S. Mint

My mistake, I holler
but poetry comes first
democratizing confluence
despite terror greed

No big deal, larger than life or death
I hear fifes in the outward calm
granite humps and chins
sweet sizeable orpiment
seldom repetitive, un-saying the echo.

TANGO

for Liz Rideal

Maybe we need another word for nature
would chaos do
largely friendly lately it has been a confidant
right up there with actuality, another word that insists on being

all leaves and unfigure-out-able turnings
a fork holds up the air sky
its trident mirror image jabs over eons into the
deep dark snuggle

That wanderer's length is a bird-colored
click on deliquescence
shave off the finer hairs
you might find a face

dismissive of skepticism
an opaque residue
where fibers lunch on
circular bugs, or vice versa, affinity, figure and ground

coterminous with
a sapling dressed to the nines to dissemble
launching a lecture or panel discussion
on troubled paradise

lightning strikes but once, as ever from the ground up
I like to sit in its lap
the stellar urgency of this life
actual in less than date and time

GLORIA

A large u.s. flag
flaps loudly
outside our dining room,
suspended on a pole
from the topmost balcony
across the way.
 I keep taking it
for some poor thug
running through the late
September night, sneakers smacking.

EXHIBIT A

I had a meeting with
a senior advisor
to Bush. He
expressed the
White House's
displeasure, and then
he told me something
that at the time I
didn't fully comprehend
but which I now believe
gets to the very heart of
the Bush presidency.
The aide said that guys
like me were "in what
we call
the reality-based community,"
which he defined as
people who "believe that
solutions emerge from
your judicious study of
discernible reality."
I nodded and murmured
something about
enlightenment
principles
and empiricism. He cut me
off. "That's not the way the world
really works anymore,"
he continued. "We're an
empire now, and when we act, we create
our own reality.
And while you're studying

that reality—judiciously, as you will—
we'll act again, creating
other new realities,
which you can study too, and that's
how things will sort out.
We're history's actors
and you, all of you, will be left
to just study
what we do."

TIFFANY'S SONG

Once you've been chided often enough
For letting your mind stray far from home,

The sun rises on
Durable moorings.

Squirrel and owl cavort
At the loosened collar of the nasty wood.

The trees grow straight and tall
Around the bend, scribbling rent checks

To absurd obeisance. At the sight of a mouse,
The seasons revert to blended gridlock.

Weird mouse.
Local authorities have found our ship.

SONG FOR CONNIE

The sun met the moon at the corner
 noon in thin air

Commotion you later
 choose to notice

Love shapes the heart
 that once was pieces

You take in hand
 the heart in mind

Your fate's consistent
 alongside mine

Unless a mess
 your best guess

That is right, thanks, the intimate
 fact that you elect it

At corners, dressed or naked, with lips taste
 full body, time thick or thin, fixated

Love, take heart
 as heart takes shape

And recognition
 ceases to be obscure

One line down the center
 another flying outward enters

"I THOUGHT THEY WERE BEAUTIFUL BUT THEY'RE REALLY GLAMOROUS."

(Bruce Conner on Nathaniel Dorsky's films)

Philip Whalen directs failed eyes toward the whirring Bolex.
Between thumb and forefinger the perceptual moment clicks:
"The camera is the world. I love the world."

FOR THEREMIN

Come dusk, the unwary knight steers his swan boat towards a lone spectral damsel despairing grievously on the opposite shore. French horns talk, then cease abruptly. Freeze-dried pathos mounts as evening assumes its calamitous dragon shape. Those scales make explicit an iridescent splurge of spiritual sighting. Slender willows exchange *pensées,* arriving apace at the shared understanding that self-help is as useless and impenetrable as the blanket arbitrariness of class determinations.

GLASS HOIST

The dictates of history are not of this world.
Plentitude and transcendent artifice
Unhinge the gates.

Overlooked commonalities remain negotiable
Upheld by those whose sense of touch
Runs counter to the claim of vision altogether.

BUT THEN
for Anselm Hollo

Nobody knows
the trouble—the wasted
whistles, catcalls, oceanic blitz,

 diehard
 push-button
fashion-conscious
 expressivity.

OUR FRIENDS WILL PASS
AMONG YOU SILENTLY

You hope the Earth is equitable,
Because why else are you here,
Fraught with the extra time
And sure-fire energy, clear
And in the same breath, not.

Garbage, detritus, commandeers
Much of each day,
But materiality doesn't look that way to a peanut
Nor yet at us, prey as we seem to be
To the intimate void granted to assuage the even bigger abyss without.

Beams keep solvent if unpolished in
Amassed yearly vaultings.
Crumbs and contouring in an antique frame
Compound the sands they shift and bear the foot
Traffic along its jagged route.

Old Walkway, you who are traditionally mistaken about
Your portion of this well-whittled master plan,
How phenomena lodge
In every filter and grander
Conceptions dance the Life-form Jack.

Sorry about what passes as fact
In emboldened dot patterns, extended fingerings
Like Norway's prettiest tree
Against clouds' residual entertainment brought home
To meet our obligations should pockets fail.

FOR PER HENRIK WALLIN

Intentionality, can't hear you for the din

 no sound in sight, inheritance

 if listening is endearment, but impervious

 a liberty positioned tight

 in the still of the night

a handful of stars

ART DIARY

for David Meltzer

Estes looks good here
Celmins exquisite,
and everything about that Brillo Box
achieves its lucent quiddity in time.

A New-Age showboat
of vinyl and kapok,
lithe bodies and retroactive fruit
film a sense of being at the event.

All are "expressions," each a ritual trick
with multiple crotch marks, lineaments,
cultural signage like metaphoric cleft chins
and precepts beyond

their facial contours. In a dark map,
Government Dog bites Everyman's butt,
and the worry lines on Mother's
brow deepen.

Remember when cognition could walk and talk
and copyright desire?
True, art today won't work like that—
funny-peculiar, not ha-ha.

GRAND VIEW FRAGMENTS

Accommodation

One was reading *Welcome Home Lovebirds*
I was subbing for X who was sobbing for G,
 slobbering constantly
 over the sink
 Only spelling counts
Sundays the car gets washed
 Fuzzy shadow on the page of someone chewing gum,
 vowels expostulated in a row,
 end to bitter end
 across long rasping continents

 Buttons and Bows
 Boots and Saddles

What with this wild and crazy relativism
 born to be written:
 a speck
 —a what?
 light, mere light

The Origin of the World

an unmentionable painting by Gustave Courbet,
 a crotch shot,
 a very good deal to begin with
 by that otherwise somewhat cheesy artist
 provenance: Jacques "Doctor Gaze" Lacan
 curtain décor by the estimable André Masson
 preproduction photography: Auguste Belloc

Raw stupor rules—

unpopular war insists,

 a suicidal impulse, at best,

 which may be why

 the typeface increasingly

 appears

 smaller, reduced,

 diminished,

 debased

 One of us recalls the found

 letter and he who found

 out her side of the story

 there

Alice, Brigid, Miriam, Rusty, Eve,

 Bunny the girl next door

 the last Andy Warhol impersonator

A.K.A. THE PANTHEON IS FLOODED

If only you had had the pep,
History would have been altered by your step.

Puttering in the poetry patch,
Inspirational, but here's the catch:

The copy editor hasn't called,
My pet worry's fraught with holes.

Plotting, patterning, preface confused—
The milk seemed all right but then curdled at

The boiling point, a Vermeer sort of melt,
Viscous velocity of borderline. All

These books that poets fill while I
Trespass as a pigeon might,

Banana in exhaust pipe, light brown on top,
White below.

Bearing honeycomb externals.
We had just pulled up at the curb when

Inspired, I threw down the book, turgid trash heap,
Fount of useless information, sexually explicit

But nevertheless alone.

COMPASS POINTS

All over herself
Thing said to my face
Blank of luster
To which ledges speak

Thing said
Correct objective
With slight bias
You or your dog

Oh disturb
The kettle to Edvard Munch
Assembly of ditches
Horizon asserts

You or the dog year
Dumped by the seaside
Pudding the sun never soaks
Beggars events

How quickly absorb, spoken cabal
Over moist mist recital
Slips ultimately left vertical of her being
Blistering, sea starts, brought, you tease

CUBAN FIVES

for Kit Robinson

Time the sound of what is more
Look sharp allow this clunk
Heady malice
Odd items situational is affect, loan
Just as "lusts" make clear mimetic physics

One question is traditional
What did the lady forget? or did you leave behind?
If anything, mature clowns stare
Create for press shots
Tidy inertia astounding remains he builds

Please acknowledge
There is music there too
Especially in some of Mahler's 7th
The viewer's headgear and little teeth
Rolling down on Salsa Sue

Wait for nature's tsk
Take the bait for lunar task
Last flowers doom nowadays arctic mull
Kiss-off kiss closet language leagues
And the horrid roll remains

States listings classes principles codes
Lumbar classics of a blue tin enameled bucket lakeside
But at maneuvers you stayed
Soft under the pout fumes
Events outer to mind beckoned

Militant male member
Pound of the ocean kit
I tell my friends
That's the end
Gifted female elements knocking

Just a phase at midday
Like money in the bank
Enormous portion ruined
Thirty seconds in love
Carved in animal court

And attendant crypts
An Alp's reunion here, but there
Rides negative ecstasy
User perfect,
Creep

A clitoris stuck to the tongue
Expenditure's private
Smatter of taste
For beans and sub clauses
Accommodating the spectral nozzle

Spelling integral pecks on the cheek
A straw person I once had
Occasion to observe
All-out attack on a one-of-a-kind
One of those on a heave

Tuna shoes
Suction the nonce
Everything on a windy day
Hooting through the brush
It is spring in the desert

As married people do
With mangled saints
Call of white heart
Loss
Once the remedial shelf

It is Easter in the phenomena
Each wandering soul
Open to suggestion
And the night sky less confounded after
New grass with old

Which is why a soul kiss
Beetle Bailey pounds the mess hall counter
With Sarge's head
Insubordination
Azalea, either way a time-worn mesh

Phosphenes dabble in a field guide
For dead elephants
Tangents pour afoot
With hemoglobin on the way
Engender feats of caution

How operative
A doorstep on a star
High-definition clouds
One lung two tongue
Each thread a cluster into package slant

WITHOUT PENALTY

As Traffic School becomes the ruling
Paradigm of higher learning

And the citizenry pays dearly
For the right to witness ex-CHP officers engaged

In fitfully polishing
Their monologues, hopeful, at best,

Of high-end careers
On late-night Cable,

It's not so much the shame inflicted
As the concomitant displays

Of the eternal drunken car chase divided
By Infinity's irradiated speed bumps,

Careening en route
To regime change, permanent and without end.

A RECORDING DEVICE

Well, back to my ablutions then.
You never walk in the same movie
twice or feel the traction between
experience's proprietary sleepless
light pervading the girder's
 unclouded eye.

You will want to lap the sheen off anyone's personal orifice
to imagine vapors crossing the grid's white string
 wrapped
around a rusty nail, sweet denim moon swallowed up,
 coercing landscape lovers
 articulated.
 Between action-packed earth
 and acquisitive skies
 there's a job to be done:
 spatial distances
 simply minding parked cars
in suspicious places—the shrine of matter, perhaps
 ephemeral yet.

ON CERTAIN PICTURES BY DIANE ANDREWS HALL

The cumulus swells, depending,
Aged or ageless, and one thin pink tousle
Crosses its dark denser other, seeking

To learn of the ample ones
Allow for two, permit descriptive—
Then square the merger by combing a detail.

Smitten like sea strata, the view
Of "breakers" feeds the rise, the steep lilt to join,
Glory wash abut to top-right billow-and-fluff brigades.

You find clinchers deep in white noise,
A reef of focus sustaining
Ocean's overbite.

Perceived against the eerily orange
Neon zinnia, the exquisite goldfinch
Takes naked nerve.

The surround—Sensibility, you can smell it in a flash!
Synaptic hole punch, dire pinch of the Greater Photon:
My mind has a flash wound.

The flowery instant flits,
Gone chuckling, rinsed
Down the fabled lane.

Daylight on a wall inspected
Enlarges to plank-like angles—
You go there, mentally, refracted.

Light shows the way the day goes,
And if distinction follows the sense of it
Can be only gratitudinous.

A child of this shimmer,
Swimming as fast as I can,
Paddling that summer, I fell down.

A painting's squared-off bloom of surface apprehending,
Ordinary, caught, aligned, benign,
Neither literal nor not, and not a mirror, after all.

SHE HUNG UP

for Carlos Villa

Shadows fall from bricks
In the line of fire without a song
You do the math
People talk and carry on

In the line of fire without a song
An escalator cannot divide
People talk and carry on
Esperanto études at Weather Wall

An escalator cannot divide
Many pink petals in a vortex of Oreos
Esperanto études at Weather Wall
What gravity is, knowing how the light

Many pink petals in a vortex of Oreos
Earth tones escape the citrus ouch
What gravity is, knowing how the light
Like Russian theft comes minimal, minimized

Earth tones escape the citrus. "Ouch,
Love is a loading dock
Like Russian theft" comes minimal, minimized
In/ out, in/ out, in/ out—but only somewhat slightly

Love is a loading dock
She hung up
In/ out, in/ out, in/ out—but only somewhat slightly
A bouquet of crates

She hung up
They were flint chippers in high school
A bouquet of crates
Quel drôle de vie of Green Card agapanthus

They were flint chippers in high school
Your tentative liabilities awesome as a news hour
Quel drôle de vie of Green Card agapanthus
Let the sunniness of Classicism shine

Your tentative liabilities awesome as a news hour
Shadows fall from bricks
Let the sunniness of Classicism shine
You do the math

ON *WEST SLOPE*

The light in Lincolnville today is clear—the trees show it, seem to know it, so to speak, in their bones.

Light falls and fractures, making stays, tethers, refractive blip and clatter.

Moss accumulates and/or is gathered, a green tube color a shade darker than the one mixed for leaf.

The uneven ground skitters.

The ground rises to the right; shadows seem to slip.

Light strikes the slope from stage right, raking and rinsing.

"Morning," say the oboes and bassoons and lone piccolo.

Shadows favor, and strangely highlight, the results of rough weather—strewn, broken, shredded parts—discarded branches and at least one very young, gnawed-at stump.

The sun runs temperate hands along tree trunks.

The horns say "Late summer."

The trunks are largely sturdy uprights, with some sinewy exceptions.

On second look, the sinewy ones seem to be dead limbs sticking up from larger, fallen boughs.

"Sinewy"—in the lower right corner—appears to be dancing to a different drummer.

That uncannily assertive deep brown cast, which may stand for shade and what's caught in it, beside which everything else on the forest floor looks like camouflage fabric, blotted.

A festival or chorale of leaves, assembled in one, across-the-board, frontal flutter.

Not so much "You blinked!" as a breath just emitted and sustained.

As in songwriting, there is the buildup of tension together with release.

The mind's eye, pressed flat against the factual array of fat, put-on paint, unfurls spaces.

You arrived at this spot with some purpose in mind and now stand, staring straight ahead, with no particular sense of where there is to go.

Why go?

There is life in scatter yet.

Hovering blue bits of sky are almost negligible.

A crescent slice of blue as from a cheese grader.

You don't really see it for the trees, but sky, as ever, is the Great Conditioner.

The overriding fullness and immensity that is air.

The trees are trees, with the characters of trees and like nothing else.

Courage is a clump of trees.

In the woods it's always clear which way is up.

The smooth cradle produced by a tall bleached trunk and sleek, new, brown growth sprung like a narwhal's horn from its base occupies stage front, center.

This could be the major clincher but, without posturing, soon settles back into the scene's ever-unsettled perceptual hash.

The stain of immediacy, so that the moment, reimagined as painted—in this instance, on canvas ten feet across—is made to stick.

Contour and/or articulation, then wholeness—it all takes some skewing.

Abundance is no guarantee.

Whatever meets the slope that is not itself the slope.

Which is truer, intermittence or confabulation?

And if you stepped—snap, crackle—on yon fallen leaf or twig wouldn't the entire picture fly off into a million pieces?

Chalk up that forbearance to art's unerring hand.

"The associations are innumerable. Many are discarded, leaving some behind."

In the depths a bird is singing its predestinated riff, unaccounted-for here, though applauded greatly by leaves.

POEM BEGINNING WITH A REMARK
BY RICHARD TUTTLE

*One remarkable phenomenon of my work is its love for being hung at
a height of fifty-four inches from the floor . . . This height brings me in
contact with anything that's ever existed in human life.*
—R.T., 2001/2004

Sudden outbursts may be key
So Fred Rain quipped to Henry Rust
As the diamantes fell from her veil
In Part Two of *Les Enfants du Paradis:*
Dear Waste for Good,
As far as time and tide may go
This far have I admired
The penis-fashioned clouds
Pressing on her jugular
Schlepp the multiple joule sessions of
In ripened snow
Drip nymph case spun
Such is life's felicity
Within foulard accompaniments
Superhuman venues (e.g., "sites")
Things will keep, keep them
At rest, environmentally
Speaking of catwalks
Suspension of plumb line
Compatible pocket auras
Stacked exegesis
Something an anemone can relate
The wanderer in you
Little Lulu
Eye Fool
Hath remained intact
Among dried-out figs
The miniature minister is reproved

In the funnel, funnily enough, you fuck
In sneer quotes
For what is never to be clear in any case
Sexuality gorgeous to a fault
Wiping up
Because just stepping out into sunlight
October, first of several arbitrary dates
The tiger in its nimble meekness is no less light than I
I'm . . .
Sanity's surface work
Live column of water
And everything in it alive, as well
But beware, stumped starling, khaki saint
Or get you darkening beyond your ken
"Ziggernaut" orbiting *Sartor Resartus*
Aestheticism detachment parallel to shock
Stepping water
That softens the heart
You could photograph something, anything, instead
You could be empty or dead
And get away or by—a by-product of light
And mud
Don't forget to alternate
Besides, how have we done this?
Hand by foot
A miracle
Not to mention air
A crush went forth
Sounds furthered the thought
What it might stay for
Because to work is surface
Things will be here, then back
With luminosity appended
The rest is ditto
Sight unseen, admit it

RENDITION

The song Willem de Kooning said
He wanted played at his funeral—Frank
Sinatra's "Saturday Night Is the Loneliest
Night of the Week"—never happened.

What he got instead was selected
Arias from Verdi's *Aida*—a scratchy rendition indeed,
As angelic choirs muttered softly among themselves
In unison: *"Aida*—fucking *Aida."*

TRAFFIC

Choice is painful,
Occasion but a drag.

Poems are made by poets,
That's no lie.

"What's wrong with this town,"
A New York driver says,

"There's too much art—and
Too many art lovers!"

"You an artist?"
"Nah, I just drive cab."

BUSINESS

Roses are red
The gods favor mostly honey

Containment bars all exit
Insofar as the bouncing ball

Dispenses
With unlikely arrival

What horses are to marriage
Or a pirate dish of dead man's bones

So is passionate love best compared to a fire
Ignited across a calm, reflective stream

Yours as the bright lights spin out of time
As if you had summoned them

FOR THE HEART OF THE SECOND FLOOR

Now you see it
no you don't

Not a problem put
this next to that

Time and materials
that's the work

Take-out pattern
recognition delivers

Apropos
an apropos

You recognize like the back of
nobody's business

Small pleasures across fields
of dark matter splurge

The problem lies
elsewhere

Alongside the solution
down

By the ponderous lake
raw stupor rules

Fake governance
arrogance yammers

The no-singing elephant
in the sunny situation room

Outsourced consciousness
cheat sheets

Bestow
on encrusted skulls

No news is good from
sadsack Baggy Dad

Or the cornfields
either

So it goes
absent authenticity

Under twinkly blurs
deft circularity

Story threads legible
in every bright night sky

Doused with travel plans
and grievance

Compressor smudge an index
of indelible

Opacification epithet
dire surmise default

"What color is that?"
"Marimba"

Now that light has
come back to us

Its bath of water fragments
celestial respiratory function thrives

Some mornings I can tip my cap
air antique manners in the Philosophers

Walk back reading up
on metamorphosis and pragmatism

"There are many things more interesting
about me than my name" sings one attuned

In bold magnanimity
colors squared with

Shape advancing smilingly
print to fit

AS IF YOU DIDN'T KNOW
for Ed Ruscha

Going after something word
For word the drill bit

Ruminations scattered
Notes early on

Sunny and fair
A screwy residue prevailing

Faulty logic's bulldoze function flattens
Live nerve that faster affect opens

Logic can't atone
Except the fun parts

Dire quirks and chortles blurts and fumes
Incongruity produces

Too true
At mental edges

Clarity's aftershocks
Administer in kind

Blank gorgeous fact we applaud and laugh with
The unsure subtlety

Whose inventive uplift
Resembles heaven

Handy as a name lost at first
In memory

Returned unbidden
And just as piercing

A mere slip
Like money in the bank

No rest for liquidity
Margin of error at risk

A very modern view
History cashed in

All that
In a fabulous snit

What's left? Poetry installer
Downloaded clicks

Right back at you
Nothing behind

None other either way
Same old same old story

One finger at a time
Formal silence presses down

A deep note boldly enters
On bended knee

The way music
Loves company

Those breathers arranged by twos after eons
At the piano

Such talk
Let's hear it

Imperceptible downbeat
Periodic oblivion

All thought
Suspended

Like the reckless
Parallelogram

Resident glory splinters
In that great picture of sunlight

Splendor showered on a vacancy
With just your word for it

LANDSCAPE WITH CALM

for Nathaniel Dorsky

Pronouns raise the day in kind
 search me a face

To patch
 in phrasebooks

"Say 'Ah'"
 "Arghhh"

Refresher will keep makes
 cold turn coils

For vacant-headed air
 more robes described in wheels

Brains seek crawl space
 scramble

Through towns of name
 to look

Shake out
 the instant nerve

Periphery lifts a clumplike orb
 whence whole

Eras of suds
 come elucidated

Light breath across the windshield
 the first raindrop scuttles

Mild of eye still goes by word
 of mouth of world

Your call to hold it
 completely initiated culmination's not

A childhood wish
 interminably avoided

But coming and going
 the sight of things

That intermittence contains us
 to the last blink

So much for options
 direct address

A panoply of perfect
 luster bouncing

News off the moon
 all consummate matter welcome

Once motions cross at fatal lip
 no other step will double do it

BILL BERKSON is a poet, critic, teacher, and occasional editor, publisher, and curator, who entered the worlds of art and literature in his late teens. He was born in New York in 1939 and attended Trinity and Lawrenceville schools and Brown University, The New School for Social Research, Columbia, and New York University's Institute of Fine Arts.

Berkson has published many books and pamphlets of poetry, as well as volumes of criticism and selected lectures. From 1971 to 1978 he edited and published a series of books and magazines under the imprint Big Sky. He is a corresponding editor for *Art in America* and has been given numerous awards and grants for poetry and criticism, including those from the Poets Foundation and the National Endowment for the Arts. In 1990 he received the Artspace Award for Art Criticism, in 2006 he was the Distinguished Paul Mellon Fellow at the Skowhegan School of Painting and Sculpture and in 2008, received the GOLDIE Award for Literature from the *San Francisco Bay Guardian*. From 1984 to 2008 he taught and organized the public lectures series at the San Francisco Art Institute. He now lives in San Francisco and New York.

COLOPHON

Portrait and Dream was designed at Coffee House Press,
in the historic Grain Belt Brewery's Bottling House near downtown Minneapolis.
The text is set in Garamond.

FUNDER ACKNOWLEDGMENTS

Coffee House Press is an independent nonprofit literary publisher. Our books are made possible through the generous support of grants and gifts from many foundations, corporate giving programs, state and federal support, and through donations from individuals who believe in the transformational power of literature. Coffee House receives major general operating support from the McKnight Foundation, the Bush Foundation, from Target, and from the Minnesota State Arts Board, through an appropriation by the Minnesota State Legislature and from the National Endowment for the Arts, a federal agency. Coffee House also receives support from: two anonymous donors; the Elmer L. and Eleanor J. Andersen Foundation; the James L. and Nancy J. Bildner Foundation; the Patrick and Aimee Butler Family Foundation; the Buuck Family Foundation; the law firm of Fredrikson & Byron, pa.; Jennifer Haugh; Anselm Hollo and Jane Dalrymple-Hollo; Jeffrey Hom; Stephen and Isabel Keating; the Kenneth Koch Literary Estate; Seymour Kornblum and Gerry Lauter; the Lenfestey Family Foundation; Ethan J. Litman; Mary McDermid; Rebecca Rand; the law firm of Schwegman, Lundberg, Woessner, pa.; Charles Steffey and Suzannah Martin; Jeffrey Sugerman; the James R. Thorpe Foundation; Stu Wilson and Mel Barker; the Archie D. & Bertha H. Walker Foundation; the Woessner Freeman Family Foundation; the Wood-Rill Foundation; and many other generous individual donors.

This activity is made possible in part by a grant from the Minnesota State Arts Board, through an appropriation by the Minnesota State Legislature and a grant from the National Endowment for the Arts.

To you and our many readers across the country,
we send our thanks for your continuing support.

Good books are brewing at coffeehousepress.org